DIVIDED PORTRAITS

DIVIDED PORTRAITS

IDENTITY AND DISABILITY

Hilary Cooper

Introduction by Ambassador Jean Kennedy Smith
Essay by Roxana Robinson

umbrage editions

To my subjects and those who support them.

To my parents, Kenneth and Florence Cooper.

To my husband, Chris Crowley.

CONTENTS

INTRODUCTION

Ambassador
Jean Kennedy Smith

This book of portraits gives each of us a privileged glance into the character of an exceptional group of people who have learned to live each and every day overcoming challenges that many would find too overwhelming to even think about, let alone experience. But the artist who brings these portraits to light is no ordinary person, for in the split second it took for her to take a misstep in the dark, many of the challenges faced by her subjects became her own.

In that flash of a moment Hilary Cooper's life changed and she became a quadriplegic. She tells her story as she lived out her changed fate—with guts and humor—conscious of her good fortune to have received the best medical care possible and to be surrounded by the love of her husband, family and friends. Hilary found herself in a new world, where nothing she had learned before about navigating life "worked" anymore and where even the most basic physical activities required new skills and patience. She embraced the notion that life would never be the "same" again and with the generous help of her therapists she made herself ready to be part of a new community that lives with us and among us, counting herself as one of the more than fifty million Americans who live each and every day with some form of disability.

And then the unthinkable happened again. Hilary Cooper got up out of her chair and walked. Literally. She became the exception to the rule, the "miracle" case that can now be read about in medical textbooks. But her sense of herself and life itself was irrevocably changed.

If you look closely at Hilary's portraits you can sense the acuity of her perspective. She knows from the inside what it's all about and she captures the essence of her subject's lives and the range of emotions that mark their days in a way that no other than an artist who has been there could truly portray.

Hilary Cooper's works give each of us a chance to take a new look not only at individuals whose lives have been marked by what we call a "disability" but at ourselves and our own limitations to fully appreciate the enormous potential of creativity and goodness we all share. We are fortunate indeed to have this book—an inspired portrait of remarkable people.

GRAZED

Hilary Cooper

I was asleep when March 12, 1996 became the new day. By dawn, I was a quadriplegic.

I don't remember how I got to the stairwell. I just remember being airborne head first, the mental image of darkness and a line, the railing, the snapshot taken by accident as you're loading the film. I reach out. There is nothing to grab. Then I hear an unmistakably messy "crunch" as all of my weight comes down on the back of my neck as it hits the edge of a stair. It's hard to explain my initial reaction. I have completely lost control of my life. In a matter of seconds it has changed forever. I am bewildered. I might die. I have killed myself. It's strange: perhaps because I have no choice, I seem to accept my fate as I bump down the rest of the flight and come to rest on my back at the landing.

I become another person as I assess the situation, a big sister trying to calm down the younger one but looking for the grown-ups all the same. I am talking to myself: "No, I'm not dead." Nor, any longer, do I think I will die but I cannot move my arms and legs or feel anything except a slight tingling sensation. "Help…me…help…me," I breathe quietly. I cannot yell. I can hardly speak. I can't do anything. Miraculously, in this enormous Victorian house at two in the morning, someone hears me. It turns out that a woman rents a basement apartment just below this stairwell at the back of the house. She does not hear my voice, just the sound of the fall. "Like a piano falling down the stairs," she later described the crash above her. She comes upstairs to investigate. Her face appears over me, concerned. "Don't move me," I manage to whisper, "I can't move. I think I've broken my neck." She calls 911 then summons the woman I'm staying with

and whose portrait I am to paint in the morning. A commission for the National Trust for Historic Preservation, I am to paint Dana Crawford who is responsible for preserving and restoring downtown Denver. Dana is asking me questions to see how lucid I am. I've never been so alert!

The paramedics arrive within minutes. "Can you move…feet, legs, hand?"

"No."

"Do you feel anything?"

"Yes! Tingles."

One of them is poking me with a pin. "Can you feel that?"

"No."

"How about that?"

Again and again, "No."

I wonder right then if the tingles are the last thing I will ever feel—my nerves short-circuiting.

I've broken my neck. They don't say so but I know it. I feel ashamed lying there with my knees at my chest in an old nightgown doubtless scrunched up around my waist…no underwear…humiliating. I'm asked lots of questions—phone numbers, what day of the week is it, what year, etc…to see if it's a head injury as well. It's not. I'm moved quickly and efficiently onto a gurney, out to the street and into the ambulance. My view from here on is of what's above, the ceiling, then dark night sky, bright flashing lights, shiny white ceiling of ambulance, a stranger looking down at me. The paramedics discuss which hospital I should be taken to and settle on St. Joseph's. I don't know why, nor am I consulted. The paramedic in charge is comforting me. He is competent and kind. I feel so stupid, embarrassed. "I shouldn't have had any wine at dinner…" I remark.

"It's an accident, these things happen…you're in good hands now…everything will be OK…just relax."

Now I'm in the emergency room. The nightgown is cut off. I am not to be moved. I'm catheterized. IV Heparin to avoid blood clots. IV lots of painkillers. Then I hear them somewhere above me, "How much?"

"All of it."

"Is this enough?"

"ALL OF IT."

I don't know it but I am getting a huge break, right now. They are pumping me full of methylprednisolone, a steroid. It's a new procedure for spinal injuries that prevents swelling of the spinal cord. You don't have to sever the spinal cord to become paralyzed. A bruise will do, causing the cord to swell and choke itself. The steroids give you a chance, a slim chance. I've just embarked on an extraordinary journey.

When I moved to a ski town in Colorado from New York City four years before I'd been terrified of having a terrible accident like a torn knee ligament. The weeks of rehab…the pain! My extremely active soon-to-be husband had me skiing, mountain biking, road biking, and wind surfing, all during the first six months of our courtship.

"You've got great musculature!" Chris proclaimed. "Before she met me she'd never been outdoors and only wore black," he would often comment. We'd met in August, I moved out to Aspen in December and we were married the following August. I can't remember when we were technically engaged, but it was mentally on hold many times as he ushered me from one dangerous activity to another, skiing down some ludicrous pitch, biking over a rock pile, thrown like a projectile into the foamy brine off a wind-surfer. A young buck? No, he's 25 years older than I but has the energy of a 25-year-old. I had a single wedding shower: "Sporting Equipment." The women, new friends in Aspen, sat around looking doubtful, wondering which would dissolve first, the marriage or me.

And so the irony: I did not break my neck hurtling down some double black diamond run in Aspen, or pitching head over heels over the handlebars on the Slick Rock Trail in Moab. I did it on a portrait assignment in Denver. I woke in the middle of the night in a strange house and, in my confusion, I simply walked through the wrong door, the one to the back stairwell, not the loo.

Surgery

So now I'm in the emergency room at St. Joe's hospital in Denver staring blankly at an x-ray held above me. "Look, you've broken your neck…" "you silly girl," he might as well add. "You are quadriplegic." This is about the most terrifying thing that can happen—to other people. But these people are describing ME. The tests have been run, no movement below my shoulders, a little feeling in my left foot. (Yes, I think I feel that safety pin. Everyone in this world seems to carry a safety pin.) This means I'm "incomplete," or not COMPLETELY paralyzed. I am despondent. Disbelief. How CAN this have happened? In a matter of seconds. "INCOMPLETE." Does it mean there is hope?

Next, they're talking about death. "You're lucky you're not dead." "If you make it…" Oddly, this doesn't scare me. I'm too busy concentrating on life. I feel peculiarly alive. But it's annoying to me that they keep mentioning that possibility. I simply dismiss these remarks.

I am very cold and thirsty but the nurses won't give me anything to drink, just ice cubes to suck on. Liquid would not be good because of the anesthesia needed for the operation. OPERATION? "The surgeon has been called. He is on his way." Surgeon? And I have no choice…who will he or she be? Poor thing. What a bother being awakened at three in the morning. (Or not, maybe he's right here, a first year resident ready to practice on me.) I am chagrined at what I'm putting others through. My very life is to rest in the hands of a complete stranger…I have lost all control. I am fortunate to have wonderful health insurance and can choose any doctor I want. So to have the choice taken away is eerie to say the least. (As is having one's legs and arms taken away.) I recall my college boyfriend who'd become an orthopedic surgeon. I'd trust him, but the thought of being sliced open by any one of his fraternity drinking buddies— misogynistic Neanderthals, who'd also become surgeons— is a nightmare. The movie *Animal House* comes to mind. It was based on his Dartmouth fraternity. In fact, these guys are the only surgeons I ever knew. No, that's not entirely true. Mustn't forget the American medical students I'd met

when I lived in the Philippines, there because they couldn't get into any med schools in the States. Really positive thinking. Anyway, I haven't met any surgeons lately. They're not part of my world. They disappeared into a parallel universe, waiting for me.

I think about Chris, my new hyperactive hubby. Of all people to be stuck with a disabled person. Of course, he'll leave me. We had planned an extended trip to Italy in early summer. "I guess I won't be going to Italy…"

"No, I don't think so," is the nurse's reply. Too depressing.

I am alone. I feel so alone. My life is changed. All new and I have yet to encounter anyone from the old one. All of these people behave as though they have been expecting me. They know what to do. I am no one in particular and a VIP at the same time. I have been received. There is a protocol. But I didn't expect to be here….

Someone applies calipers to the sides of my forehead, explaining that he needs to measure me.

"For what?" I flinch.

"For your halo," he replies.

A halo is a metal contraption that is screwed directly into one's skull and shoulder bones to immobilize one's neck. Panic. I must relax because every time I tense up, my shoulders shrug involuntarily and painfully lift my arms up over my head. There is an imbalance. The shoulder muscles which are used to lift and shrug work, but the counteracting muscles that pull the shoulder down are paralyzed. To regain calm, I try to amuse myself. I recall a *New Yorker* cartoon about a portrait subject of mine, George Plimpton, a participatory journalist who has reported on everything from conducting a philharmonic orchestra to pitching in Yankee stadium. It hangs framed on his office wall. A guy on a gurney looking up at a group of masked faces in an operating room says, "Before you put me out please assure me that none of you is George Plimpton."

I think hard about Chuck Close, an artist whose work I greatly admire and who is quadriplegic. I can do this. It won't be my old life, just different—the life of the mind as

vast as before. And so I seesaw back and forth between hope and despair. He'll leave me, he'll leave me not, he'll leave me…I have the clearest sense that from now on I will be relying on the kindness and assistance of others—my husband, my family, my friends.

The most profound feeling I have—and it is a comforting one—is that at least I am "still me." (A universal cry of identity, I learn. These two words would be used as the title of the late Christopher Reeve's book about his experience of paralysis.) It's all I am—just me. This is NOT a head injury. Moreover, my mind is present—for once. In fact, the blackboard of my mind has just been washed clean and each new experience, each new face, new name, is clearly marked. There's no occluding dust. I am completely here and now, as if re-born. I remember each nurse's name as they introduce themselves, even a young candy striper, Lurana. Of course, one is supposed to achieve this happy result through the discipline and rigor of meditation, not stair diving.

I'm cold. I'm thirsty. The nurses give me light warmed blankets and I keep requesting new ones as my shivering body soaks up the heat. No water though. Nothing in the stomach before anesthesia. The ice cubes to suck on make me colder. But I am so thirsty.

By the time the bright, authoritative voice of Dr. Jones pierces the gloom, I feel as though I'm lying at the bottom of a well. His enthusiasm gives me hope. I relax and give myself over to fate. It's a relief and I have no choice.

From now on I'm part of a process, a very specific one. They put me in traction. It sounds benign but is actually pretty hideous. Both sides of my head are shaved above the temples. Tongs, like ice tongs, are attached to my skull, right through the skin to the bone, to get a good purchase. My head is pulled to relieve the pressure to the spine. I've never seen it, but Chris says it was the single most terrifying thing when he first walked in and saw me.

Dr. Jones spends a few hours preparing for the operation, a realignment of the vertebra, decompression of the spinal cord and laminectomy (get the shrapnel out of the

canal and replace the disc with bone harvested from my pelvis), and a front and back fusion of the 5th and 6th cervical vertebra which are now pretty much detached from one another. Indeed, before traction they were at right angles to each other. More x-rays, cat scans, and an MRI. His voice becomes very familiar "great going…just try to be still." His focus and intensity is comforting.

More waiting. Someone introduces himself as the surgeon, which confuses me: I've already met the surgeon. But this is a second one, Dr. Johnson, and it turns out that he is the neurosurgeon. There will be two of them because it is not going to be easy. Roughly speaking, orthopedic surgeons deal with bones. Neurosurgeons deal with nerves. In effect, Jones is the carpenter and Johnson is the electrician. In fact, each can do both jobs, but I'm such a mess that prudence requires both, and each assists the other in their respective areas. Because there is so much bone damage and so much hardware needed to stabilize me, Dr. Jones is in charge.

Finally he needs my consent, orally of course since I can't write. He reads out the dangers. "This operation may result in partial paralysis, full paralysis, death…is there anything I left out?" he asks Dr. Johnson. I hear a low murmur, "Oh yes, you may have a little trouble swallowing."

Pathetically, I ask if there's a choice. All assembled look sadly down. No, I don't. I consent.

Chris has long since been called in Aspen and is on his way. He reaches me just as I'm being wheeled in to the Operating Room. "Your wife is in bad shape," they told him. They describe my grave prospects. Then they tell him, "Get here as soon as you can, but don't speed. In fact, is there someone who can drive you down to Denver as you might be too upset to drive safely?" No. He later tells me that he's never been so depressed as during that four hour drive, worrying about me…thinking about our new life. Where's the best place to live with someone in a wheelchair? There were no obvious answers.

Early in the relationship, we had talked about the fact

that he might be a burden on me, toward the end of his life. Also, I might have to make some tough decisions about life-support and all that. "Many people," he used to say, "when they are too old and sick to be any use to themselves or others, do not want any more heroic measures to keep them going. Not me," he said. "I want everything. If I'm down to one flipper, circling round and round the petri dish, that's fine." It became our joke.

And now he's here, looking down at me and I up at him. He's the first familiar face to block my view of the ceiling. He's wearing a jacket and tie, the tie he'd worn on our wedding day. I tell him the awful things they have just told me, to get my approval. That I may very well be a "cripple." "Don't worry," Chris says, "First one to the petri dish wins." I am wheeled into the operating room, laughing softly. And, most importantly, now I know he's there for me, and will be. In that frame of mind, I'm wheeled into the OR, where the anesthesiologist kindly exhorts me to swallow a tube. Then I'm out.

I wake to the voice of my anesthesiologist, Ron Hatten, who is pleased that I'm coming to so soon after the operation. It's about seven in the evening and the operation lasted nine hours.

I'm in the ICU. I can't move. I have to blow on a ball, which is attached to a wand, to summon the nurse and I do it a lot. I can barely breath and keep needing to blow my nose. I feel claustrophobic. At one point the nurse forgets to return the ball to its position near my mouth so I have no way of summoning anyone. It is terrifying and he is extremely apologetic when he discovers his mistake. The next night nurse is not so nice. "You can't be this demanding when you get out of the ICU."

I get out of bed, walk to the door, and as I'm turning the knob…I'm back in bed. I've just hallucinated the whole thing. I am completely helpless and immobile, unable even to shift in bed.

Chris feeds me jello, spooning it into my mouth gently, but I'm not hungry so he eats it. He loves jello. "Someone was supposed to be feeding someone jello in this relation-

ship but it wasn't supposed to be this way round," he observes. I guess the "for better for worse" has just kicked in and Chris is there and tender and loving. I am blessed… so lucky!

Pete, Chris's sister, is by my bed. Pete hates to fly. She'll take the train across country and had done so just the previous month. "I must be in BIG trouble if you're here," I say to her.

"It's OK," she replies. "At least there was no anticipation."

Visitors come and go. The crowd swells since Chris loves a party, and the more the merrier. Oddly, it is merry.

"Wiggle your toes, honey," Chris commands. There is slight motion in my left toe. It happened for the first time last night. "See!"

My friend Anne Childs calls. When she heard of the accident she called a friend of hers who happens to be Chris Reeve's sister-in-law. "Can she breath on her own?" Deborah asks. "Yes, I think so." Anne replies,

"That's the sun, the moon, and the stars; everything else is extra."

Dr. Jones comes by on Thursday, three days after the operation. It's the first visit of his I remember. I can slightly bend my left leg and I feel something in my right. "You're the come-back kid," he says. In his sunny enthusiasm, he's the only one who offers a favorable prognosis. "I wouldn't be surprised if you actually walk into my office some day."

We are amazed as no one else dares be so optimistic especially when questioned directly. "Return" of sensation and/or mobility can continue for up to a year and a half but can also halt entirely at any time. However, I am making progress. A bed becomes available at Craig Rehabilitation Hospital on Friday and I'm transferred. "How long do you think she'll be in rehab?" Chris asks. Any time up to about a year is the vague answer.

To summarize my condition: I have broken my neck between the 5th and 6th cervical vertebra and bruised my spinal cord. The cord has the consistency of an unripe banana and is suspended in the canal in fluid. The space around the cord differs from person to person. Some cords fill the canal. I am lucky; there was enough room that even with the enormous amount of bone displacement, the cord was not severed. (Although the ER doctor on duty said he'd never seen an accident as bad as mine where it wasn't severed.) Nevertheless, the cord does not have to be severed for one to be completely paralyzed. Indeed, a bruise will do it, a bruise that on any other part of your body would go virtually unnoticed.

I am an incomplete quadriplegic. This means that I am not totally without some sensation or motion in any of my four limbs. That they are all neurologically affected makes me a quadriplegic. So I'm a C5/6 Quad. My arms and hands are more affected than my legs and feet. This is called Central Cord Syndrome. The right side is more affected than the left. In short, I can slightly move and have some sensation in my left leg and foot. I cannot move and have absolutely no sensation in my right hand. I am right handed. It is the hand I use to paint, to work, and right now it is dead, the deadest part of me.

Rehab

Craig Hospital is one of the best rehab hospitals for spinal cord and head injuries in the country. It's where you go to learn to get on with your life. Within an hour of my arrival, Dr. Menter comes by to introduce himself. He is the rehab medical doctor who heads one of four teams, each of which is composed of a physical therapist (PT), an occupational therapist (OT), a recreational therapist, nurses who meet my medical/drug needs, and nursing technicians, "techs," who are responsible for everything else including clothing me, cleaning me, feeding me. Menter is the senior doctor. However, compared to the rock star surgeons I'm used to, "Jonesie" as Chris now refers to Dr. Jones and Dr. Johnson, Bob Menter is a low key country doc complete with a little black bag as he makes his rounds.

I question the nurses to see if I have a choice. Is Menter "the best?"

"He is one of the world experts on bowel and bladder management," offers Priscilla, a nurse.

"Hmmm, bowel and bladder you say. Is there someone here whose specialty might be hands?" I inquire with concern. Silly me, I have yet but will soon learn that bowel and bladder function is at the heart of spinal cord injury rehab. As any ninety-year-old can tell you, it's at the heart of life. It's ironic that by missing the door to that bathroom, I'd be dealing with all things lavatorial.

And it's not a fun learning experience let me tell you. Weeks later I'm in the hallway chatting with my next-door neighbor, Kevin, at Craig three months already after a hit and run left him paraplegic (paralyzed from the waist down). He's used to "programs," which involves a suppository inserted once a day to produce a bowel movement. I complain that it is one of the most uncomfortable and painful experiences I've ever had.

"You feel stuff? You're so lucky," he observes, "Me, I smell something and I know I'm done."

"I am not lucky!" I retort, "If you hear noises coming from my room that sound like an orgasm, let me assure you that these hands do not work!" We become fast friends as we share the same sense of the ridiculous.

The same afternoon I meet Dr. Menter, Chuck Hammond, my physical therapist, also introduces himself and tries to get me up and into a wheelchair immediately. He is a gentle giant who lifts me effortlessly as he transfers me to the chair. I practically throw up and pass out, my blood pressure is so low from lying supine for actually less than a week. It doesn't take long for the body to decline and the muscles to begin to atrophy. Still, I am heartened by having sat upright even for a few seconds.

My first morning at Craig, I'm a born-again infant, being fed and bathed and clothed by an African-American "tech" named James, a sweet, soft-spoken man, in his early 30s and the father of seven. He's my day, or primary, tech. That first day I meet him I'm babbling on. "Of course, you may well wonder how I did this….I moved to Colorado a few years back, learned to ski, was so good that I began racing. Yes, Grand Slalom missed a gate though and…OK, I fell down some stairs." James just smiles. He's heard it all before. I feel the need to ameliorate the situation with humor. I need to laugh…or cry. The staff at Craig makes it easy to opt for the former.

"Tell me the weirdest way someone became paralyzed," I ask Pricilla, the nurse.

"This couple was making love on satin sheets, you know, no purchase and in the heat of passion the guy just skidded off the bed…"

Believe it or not, stories like this strike us as very funny. Humor is a salve and it tends to the black.

Chris had been advised to "manage" the number of visitors, and he does. I have so many that I am moved to a single. Not exactly what the doctors had in mind. I should say "we" as some were just as concerned about Chris as me. Flowers poured in….and notes, letters, chocolate bars, granny nightgowns, snuggly pillow cases, books, books on tape, CDs and on and on. It was the height of the spring ski season so friends visited as they passed through Denver before and after ski trips, some even heading to stay in our Aspen house.

This part, the support from family and friends, cannot be overestimated. The only time I felt despondent during the whole ordeal was when I first landed in the ER. I was alone. Chris had not yet been called. I was staying with an acquaintance so none of my friends knew yet what had happened. Alone, I was in despair. Chris's support and then the subsequent warm outreach of so many friends, acquaintances and strangers carried me through those fearful early stages. A group card from my yoga teacher and class reminded me that yes, mountain pose (simply standing), really is the most amazing and challenging pose.

Therapy

Physical therapy and occupational therapy are roughly divided at the waist—PT takes on the lower extremities (formerly known as legs) and OT, the upper extremities

(formerly known as arms). Our days in PT are spent learning to make "transfers," formerly that was money from one account to another, now it's oneself from the bed to the wheelchair, to the car (advanced) or wherever. It's the therapy taken the most seriously, as it is central to paraplegic rehab and the most difficult for quads who have limited or no use of their arms.

It's still the first week, and Chuck, my hunky but earnest PT, walks into my room with Mitch, an equally buffed ex-Navy Seal, now a PT in training. Chuck announces seriously, "We need to remove your clothing and submit you to sensory testing beginning with light touch."

He goes on to explain that these are tests to determine what, if anything, I can feel, and whether the sensation is "impaired." That means either "vague" or "hypersensitive"—almost painful reaction to minor touches. The skin is divided into dermatomes each of which is fired by nerves originating from specific vertebra. So Chuck lightly brushes the skin just behind my ear as the baseline sensation (lovely) and then tracks along the nerve pathways below the affected vertebral levels. To each touch, I respond, "Yes" (there is feeling), "No" (there isn't), or "Impaired," which is duly noted and recorded next to the vertebral level affected. Sadly, this is followed by the, by now, all too familiar pinprick test.

Gallows humor is common to patients and staff. There's a squawk box located over my head, often making it difficult to sleep. Announcements, pages calling nurses…you never feel alone. Then eventually, you barely notice it anymore. One day, after it had been repeated intermittently, Chris notices one announcement. "The dance tonight will be held in the fourth floor ballroom at seven." And we realize there is no fourth floor and none of us can dance and it's April 1st!

April Fools fell on Monday that year, giving everyone the weekend to plan. Conny McClintock, one of the PTs and a well-known prankster, was helping move a patient with a bad bedsore. After weeks and weeks of devoted care and attention from his nurse, it had almost healed. As the patient was moved, Conny looked down and uttered a low "OH NO!" raising a blood-soaked hand. The blood was perfect—not too red, not too brown. She'd worked on it over the weekend. The patient cheerfully was in on the joke.

Later in the day the joke was on Conny as she cut into a celebratory cake brought in for her by the sister of my neighbor, Kevin Brown. It was six months after his accident, three months at Craig. That very morning, for the first time, from lying position, he had been able to roll over, get up on his elbows and sit up by himself all because of the therapy given him by Conny. This was one of the most touching moments of my stay at Craig. It meant so much to Kevin and his family—another whole level of independence. There wasn't a dry eye. And yet there we all were, giggling as Conny cut into an iced cake confection about the size of a roll of toilet paper—because, indeed, it was a roll of toilet paper.

After my first couple of weeks at Craig I'm due for my period. What will I do? I panic.

"Honey, after the trauma your body's been through, you won't be seeing THAT for a good long while, and when you do we'll get you a female tech if it makes you feel more comfortable."

Next morning, James comments, "Well, well, look what we have here…" No muss, no fuss, no problem. He takes care of it with grace. He is the greatest. But I think that was the single most sobering moment when I realized that I wouldn't even be able to change my own Tampax and had just had a man do it, no less. Even more than having to have help to produce bowel movements. Maybe because it gets to the heart of one's sexuality, maybe because larger chunks of time would now be marked, months rather than days.

Chris arrives with Aengus, our weimaraner, having arranged for permission on the basis of "pet therapy." Oh, how I've missed his little doggy self. Angy runs around the room snuffling and then places his front paws up on the bed and

looks at me intently with his lovely celadon eyes. My lovely gray velveteen pup with the floppy ears. I lay my still hands atop his lovely silken soft head and feel….Brillo. The impaired feeling, the hypersensitivity of my hands is such that it hurts. I am filled with sadness.

"Today, we'll make cookies," chirps an OT. I've been there a month and have grown tired of occupational therapy. The use of all these strapped on utensils to aid in the "activities of daily living" is tedious at best and a constant reminder of how dead my hands are. The flour, eggs and sugar are in the bowl, and she disappears to find the electric mixer. With the bowl in my lap I wheel over to a young strong para, "You mix it, you get half," my opening bid, "Two thirds," the counter, "Deal." "Very resourceful but perhaps you're missing the point," says the OT on her return.

Perhaps my favorite therapist was Conny McClintock. We had a session each day in the afternoon. Each day was the same. We'd get little done as she'd tell me jokes and I'd laugh uncontrollably. Chris was horrified by my growing repertoire of the most disgusting jokes. One day Andy, an extremely "high" quad wheeled by in his sip and puff wheelchair and said to Conny, "I can't believe you actually cash your paychecks" referring to the seeming lack of traditional therapy evident by our howls and giggles.

Andy's a great guy, really charming, indeed something of a ladies man it turns out. "How'd you get here," our friend Jack Tigue asked when he met him in the cafeteria the first time. "My wife shot me," Andy answered. "Bad shot," Jack returned. "No, great shot. She wanted me to suffer." He did have a supportive entourage including, as it happens, a devoted girlfriend. That day I comment to Connie, "too bad about Andy."

Always irreverent, she replies, "I wanna know what he did to deserve it…."

Peculiar to the spinal cord injured is the phenomenon of ranking ourselves according to the level of our injury. Instead of cursing our fate, we felt lucky not to have met the fate of those one vertebra level higher, and we grouped ourselves accordingly. Paras stuck together. "Low" quads were glad not to have met the fate of those unlucky enough to land in sip and puff wheelchairs. (Breathe in: forward; breath out: backward, and sophisticated adjustments in between.) They, in turn, feel fortunate not to be dependent on breathing machines, and those who are so dependent, are happy to be alive and "Still Me." In Chuck Close's words: "When you're in the hospital as a quadriplegic, it's very funny: You don't envy the able bodied. You envy paraplegics. If only the upper half worked, then everything would be all right."

"The sun, the moon, and the stars" are but one vertebral level of function away.

Bill Whiteford, a friend of a close friend of ours, and a quadriplegic, visits. I had heard of him before my own accident. Ten years ago in Mexico, after a few margaritas, he dove into a lagoon, only the tide had gone out. He did not receive the immediate care I was lucky enough to have and very nearly died, first by drowning and then through neglect in the hands of the Mexican authorities. A geologist, he was a rising star at Texaco at the time of his accident. Now he lives completely independently in Denver.

During his visit I was distracted and puzzled because I was feeling a new sensation. I needed to go to the bathroom. But, of course, I couldn't get out of bed. Turns out my bladder bag was full. I hadn't experienced this before. Bill noticed, wheeled over, detached the bag, emptied it, and reattached it, no big deal. What a cool guy. (Chris, who's squeamish about all such things, leaves the room whenever the bag is emptied, as if I were sitting on the toilet.) Bill notices the stack of books by my bedside. "Tried any?" then he mimes an attempt to lift a book to just over ones head and then the inevitable crash. "Art books can give you a real headache." I think he's adorable. On the phone, I tell my close friend, "Katrina, I've just met the guy for you." I give her the good news. "Thanks a lot. Since I know where you are I can only imagine. Is he paraplegic?"

"Quad," I correct, "and really great."

A friend of mine refuses to show her work in any art shows with "women's" in the title. "It's like the special Olympics!" she complains. I agree, but even so, when Hillary Clinton put out a press release stating that she wanted to have a woman paint her portrait, I shot off one of my brochures—but not before the usual postulating "…I would HOPE she'd select me based upon my abilities regardless…etc, etc." So now I ask Chris to take down a letter "Dear Mrs. Clinton, not only am I a woman but…"

In a way, it's payback time for all those "special" and "challenged" remarks—so it came as something a surprise to me that I felt…well…"special." (I'd learn later that "special" refers to those with cognitive more than physical impairment. There's a whole disability lexicon out there, and I'm still learning it.)

"It's like this exclusive club, only there's no waiting list," remarks Chris.

Also, the club is democratic. Anyone can join. While I was at Craig, there was a scary looking Hell's Angels biker who was shot in a bar and rendered paraplegic. His body was covered in tattoos he'd collected in prison. While we're in the heated therapy pool together, a friendly looking man, a para, wheels in to say hi to Karen, the therapist. He's an alum. I ask him how he was injured. "Gunshot wound," was the answer. The ex-con perks up, "Gunshot?" he repeats, hopeful for a compadre.

"Yes, in the army I was caught in some crossfire in Jerusalem. I was air lifted to Germany and…"

The biker slumps. Not a kindred spirit after all. Later, loitering about in the hall he's passed by a gurney holding the latest admitted, a lady who'd been thrown by her horse as she was riding to hounds.

About a year before my injury, at a workshop, I'd met an artist whose husband is quadriplegic. He'd been injured during their engagement. When I met Laura she was pregnant with the first of their three children. I remember wondering about their lives. I looked forward to getting to know her and meeting Mark. I spoke to them on the phone from Craig. I must have sounded strange as I joked about everything. He commented that I didn't sound very blue. On the contrary, perhaps because each day I saw a little improvement, I was practically euphoric. My attitude might have been annoying to those around me who were not improving but I don't think so. The anger comes later as the reality of really having to cope hits home…at home. In the hospital, we all somehow considered this experience to be temporary to some degree.

As a counter-point, Chris had a very different experience, which became clearest to me as he proof-read this account.

"It's OK, but what about the horror of it! Try to express the way you really felt at the time!"

Honestly, I was OK with it at the time. I was too busy dealing with the present to be thinking about future difficulties. I remember my first days in Craig, I shared a room with a lovely young woman who had been in a car accident which left her paralyzed at C3/4, or ventilator dependent. Those first few days I was lulled to sleep by the rhythmic sound of the ventilator and roused by the call for "SUCTION!" to remove the excess build up of phlegm from her throat. She had a large and loving family and a fiancée who'd been with her, seen her being thrown from the car. There was no crying, just deep gratitude for the miracle of being alive.

Chris dealt with the "horror" in his own way. For a start he took an apartment in a nice part of Denver, Cherry Creek, and did what he does so well—built a nest. He created a home for me to visit when I could. (Transfer to a wheelchair, to a car, and back to the chair.) He even hosted the most amazing dinner for Kevin, Bill and me. Kevin's brother-in-law made the event even more festive by dressing as a chauffeur to deliver him to the apartment.

Return

Days passed in an exhausting routine of therapies and medical tests. Motion and strength returned slowly to my

legs. First there was the wiggling of toes, then the bending of the knees. Then, in the therapy pool, some tentative jerky foot falls aided by the buoyancy from the water. Nothing that would count on dry land but it was nonetheless an emotional experience for me and for Chris who was there too.

For a while I was like a hermit crab. I would propel myself around in my manual wheelchair with my feet. I was so weak that I could tell that there was just the slightest incline in the direction of the dining/therapy common area and that it was "downhill" back to my room. My arms were weak. I could bend my elbows but my hands didn't work at all—the "central cord syndrome." There are walking "quadriplegics" who have no use of their arms and hands and this was the prognosis for me. I thought, "Please God, I'll trade my hands for my legs." Of course, I'd gratefully accept anything.

Just a week prior to the accident, Ranie, my stepdaughter, visited us in Aspen with her two children. Coco, the youngest, had yet to walk. She was cruising and on the verge. So a competition was established. Personally, I think Coco was sandbagging, but Ranie maintains that we walked the same day. I don't have the details for Coco, and she doesn't remember her first steps but I remember mine.

It is Friday afternoon, not too many people about, and my main PT, Chuck, is away. John, another therapist who is himself an incomplete quadriplegic from a childhood trampoline accident, is eager to have me walk on his watch. I am standing between the parallel bars in the manner of a vet in any number of war movies but instead of collapsing to the ground in agony and frustration, I simply and purposefully place one foot in front of the other. "Well, I guess that's it then." I look up. He's beaming. It's simply a miracle.

From the point of view of those on the outside this had to be the triumph. I wish I could say I felt that at the time. Sure I was happy. But it was a part of a longer process and I was on the inside. The adventure continued. It wasn't over, not until…what? I don't know. But my perspective had changed. To walk is just one bodily function not as distinguished from other bodily functions as it would have been to the able bodied person I was before the accident. The day Chuck took me outside to master "uneven surfaces" was thrilling. Not because, as I shuffled by with a walker, a crew of construction workers on break whistled. They didn't. But because Chuck in his perfect rehab-speak announced that I was now "An Independent Community Ambulator with Assistive Devices."

Return of "bodily functions" was huge. I won't bore you with the details of what is, to me, an endlessly fascinating subject. Suffice it to say that eventually I produced a bowel movement on my own. Nevertheless, I wouldn't feel completely independent until I could likewise urinate on my own, as the inability to perform that task is far more onerous. The choice was either to remain permanently catheterized or to catheterize myself intermittently. The latter is extremely difficult, as conditions have to be so sanitary. Plus one's hands need to work. The nurses had removed my tube and were themselves performing the intermittent catheterizations after giving me a chance to try peeing on my own. I've never been so frustrated. I soon learned that the series of neuromuscular contractions and releases required are very complex. It seemed to take forever and then one evening it happened. I called Chris and put the phone to the sound of water hitting the bedpan. "The most beautiful sound in the world."

"Thanks," says Chris "but spare me."

My right hand came last. I used to lie there trying to will it back to life. "Watch! It moved. Did you see it?" I asked my friend Anne who'd just flown in from Boston. "Not really," she honestly and sadly replied. Then she'd lift the limp, still collection of fingers and yell "WAKE UP!" "Shout therapy" she called it. Still nothing happened. I'd stare, concentrate hard, ice it to innervate the nerves. Nothing.

Finally, we gave up. I was fitted for a tenodysis brace, a contraption that uses the natural opening and shutting movement of the hand through the flexion and extension of the wrist. "It's a look," I remarked to Colleen, my OT. Then one morning, I wasn't even looking, I just noticed out

of the corner of my eye: My pinky just slightly fluttering, like it was waving hi. I couldn't believe it. I hadn't even tried. The little digit just had a will of it's very own. It was perhaps the most exciting moment of all.

Anne calls me Lazarus, Laz for short. She'd sit by my bedside in the late afternoon and help me order dinner since I couldn't then hold a pencil to circle the desired choice.

"It's just like the Colony Club!" she commented, "Come to think of it, most of the members there are incontinent, too."

In a way, my experience was like a round trip aging process, thirty-six to a hundred and back. Some of the things I dealt and deal with aren't so extraordinary. It's mostly the suddenness of it. At forty-seven I'm noticing changes in my body, premonitions of things to come only I've been there, done that. Can I skip it please?

So, after two months I walked out of Craig. We all think we're going to wake up and walk out. With my injury, nine hundred and ninety-nine out of a thousand don't. I did.

Outpatient

Immediately after my discharge, I start follow up visits to Dr. Jones. I'm in a neck brace with crutches and I do indeed walk into his office. He is impressed and pleased. He calls Steve Johnson to have a look. While waiting for him to appear, I drink from the water fountain. When I look up they are both observing me. I feel a little shy under their scrutiny. Like they're two dads, and I'm the poster child.

Because of the quick effective care, "You won the lottery," Jonesie would say later, "You couldn't have been more fortunate if you'd fallen and broken your neck in the OR!"

Actually, my case is so unusual—such a great "result" after such a traumatic break—that I made it into chapter twelve of *Surgery of the Cervical Spine*, a textbook.

I had been obsessed by these two surgeons. Who were those masked men? More importantly, where did they receive their training? But it felt strange inquiring—like needing an introduction after a one-night-stand…

The night before this first visit I wake up with a start.

I'd had a nightmare. In it I ask Dr Jones where he'd gone to medical school. "Manila" was the answer. In fact, it was University of Virginia for medical school followed by a Johns Hopkins residency. He is an orthopedic spine surgeon whose specialty is the cervical spine and whose subspecialty is cervical spine trauma, i.e. broken necks. Had I done the research, I couldn't have chosen better. And Dr. Johnson, the genius neurosurgeon? I forget where he'd trained but I was amused to learn that his undergraduate days were spent at Dartmouth, I think not hanging out at any of the infamous fraternity houses where "stair diving"—the lads would first pour beer down the steps and dive head-first—was a popular pastime.

It's May, I can walk, and there's some time left on our rental of an Italian farmhouse at the outskirts of Siena. So we decide to go. I crutched through the Palio in Siena, took day and weekend trips to Florence and Venice, painted the landscape, bought chic shoes. Platforms had made a comeback and, with the aid of adjustable crutches, not a problem. The neck brace was annoying when the weather got hot. People stared at me, curious. It was the first time I had a sense of what it must be like to be someone famous… or beautiful. "Weird" didn't occur to me at the time.

In October I drove down to Denver from Aspen by myself. I had arranged to have dinner with Bill Whiteford, then an appointment with Jonesie the next morning. Just to ice the cake, after the check-up, I ran upstairs to say hi to Steve Johnson. "Do you have an appointment?" asks the receptionist. No, but it's ME. AS IF….(As if I was the only case that year.) Actually, the receptionist does remember my case because for both surgeons, all clinic appointments had had to be cancelled that long day of surgery. So now I'm just paying a social visit without neck brace or crutches and feeling very cute and proud of myself as I lost at least ten pounds on the break-neck diet and now fit back into my college blue jeans. (Even more important, my hands work well enough to be able to deal with the button fly, another crucial milestone.) As Dr. Johnson approaches, I

notice he's fingering the ubiquitous safety pin. "I've just popped up to say hi and thanks," I quickly intone. The safety pin disappears into his lab coat pocket. But there's no such thing as a social visit. While chatting, he checks out my hand and leg function, noting the spasticity (shaking) in my right leg when it's bearing weight on the toes.

"Does that count as exercise?" I ask.

"Uh, no," he smiles.

All subsequent checkups over the course of the following two years are with Dr. Jones to make sure that my neck remains stable. Eventually I offer to paint his portrait. It's poetic since the return of my working hand is due to his handiwork. Also, I have a renewed appreciation of my vocation.

When I was younger, portraiture was out of fashion, and much of it I felt was mere "illustration." I was a little uneasy to be a portrait painter. Since the accident, because of the profound shift in my own sense of identity, I feel that painting portraits—delving closely into individuality and personal uniqueness—is not just my calling, but also a high calling. I went back to it with new enthusiasm and confidence, perhaps with a greater depth. And with gratitude that I could still do it. Interestingly, within a couple of years I had a solo portrait show in New York, and been the focus of an article about portraits in the *New York Times*. Plus, delightfully, the *Times* used a photo of me, from the article, in a subway ad campaign. So there I was, big as life, in almost every subway stop in the city, painting a portrait (my subject in the photo was a little less amused).

That said, painting Alec (as I now call Dr. Jones) was difficult. It was hard to garner the objectivity required to squint and see nothing but lights, darks and color relationships instead of Surgeon-Who-Saved-My-Life Then, he was more a persona than a person. A hero. The result is a bit of an icon. All it needs is a halo (the other kind). His mother thinks I caught him precisely.

I remember wanting to impress Alec with my perfectly normal gait. I limp only when it's cold (it was warm), I'm tired (I was wide awake), I've had a few drinks (not at nine am), or I'm nervous, BINGO. It was as though my whole right side were strapped to a board. Drat! I had a huge crush on him…and Steve…and any surgeon for that matter. It's a passion that's madly, truly, and deeply fungible. Even now, after all these years, lines about me in *Surgery of the Cervical Spine* like, "Posteriorly, there is interspinous widening and/or comminution of the lamina and spinous processes, consistant with posterior disruption of the osteoligamentous complex" bring back the magic. Further on, however, "[injuries like this usually result in]…loss of all motor and sensory functions…" just gives me the chills. He tells me it's about the worst accident he's ever seen anyone walk away from.

Had this accident happened now, Alec, for one, wouldn't have been there. Tired of the crushing demands of insurance companies, he left private practice to join an HMO and does relatively little trauma work now. I'm sure there would be someone else, but our health care system isn't offering the incentives for what is incredibly difficult and self-sacrificing work. And from what I hear, "rehab" is more like "reorientation" now. Patients are barely able to sit up before they're stuffed in a wheelchair and shown the door. After twenty years, Conny quit. She was tired of having to start each sentence with "I'm so terribly sorry but…" That parallel universe is losing its cushion.

Epilogue

It's been seven years since the accident, and I've skied every run I skied before and then some, bicycled a century (metric), and hiked the Inca trail. I've been fearless, or at least much less afraid than I was before the accident, as if I'm bionic. On the weekend of March 12, the fifth anniversary, Alec and Sue, his wife, came to visit us in Aspen. We've become friends. His older daughter Catie visits us regularly. She is like a daughter. We bonded when I painted dad's portrait and it's been a special relationship for me. Her sister Aly attends my old boarding school.

Saturday morning we're discussing ski plans.

"You're reckless to be skiing," he comments.

"But, why?"

"I've told you why...I didn't repair you. You are biomechanically altered." So he patiently explains to me and Chris that without the ligaments that were stripped away, my neck does not have the structural integrity it did. It's fused at one level with titanium but above and below that fusion it is held together with scar tissue. A blow to the head or neck would paralyze or kill me. Everything I have gained I could lose. "You have to drive but you don't have to ski. The risks are too high and the results catastrophic." Funny, somehow I didn't hear it before....Denial?...Infatuation? Whatever, I hear it now. Furthermore, I'm glad I didn't take it all in then. It's as though I had a five-year reprieve.

"There's a saying among surgeons," he sighs, "Nothing ruins great results like follow-up."

Actually, Alec's lecture was the wake-up call. It did more to change my attitude about what happened than the recovery process itself. Good and bad. I am still trying to work it out. It wasn't a disease I got over. It's something I live with forevermore.

The first year after the accident, I was radiant. Nothing bothered me. I was alive and had almost full body function. I was grateful, beatific. By the second year it was time to whine about all the small defects: my slight claw hand which makes it difficult to write and count change (but not hold a brush and paint), my slightly goofy walk. I began to notice my impatience with people or situations and realize that I was becoming the same old me I was before. "But!" as a friend who survived cancer observed, "THAT'S the difference—you notice it. It's the awareness."

People remark, "You came back completely...you would never know...you're perfect." And I would explain, "ALMOST completely...not QUITE...there are SOME subtle deficits." To me, souvenirs. I sometimes call myself an Almost Completely Incomplete Quadriplegic. Those familiar with disabilities understand. But to the able-bodied it's hard to explain the notion that I'm altered. So I don't explain and accept this Default-to-Normal bias. I defaulted to standing and walking and am in the "normal" line of sight, not below it as those in wheelchairs so painfully feel. But a complete recovery? No.

Because of the awareness of my on-going fragility, I have revisited the whole experience. Besides writing this account, I also painted a series of portraits of people with disabilities. It's a way of investigating not only portraiture as an exploration of identity, but also addressing the phenomenon that just as the disabled are likely to have a strong sense of core individuality, so those in wheelchairs are still often seen as indistinguishable members of a separate group.

I have so much to be grateful for. That's what stays with me. But it's double edged. I will always have so much to lose. The specter of the chair is right beside me always. Because the integrity of my neck has been compromised, for me a common whiplash accident would very likely result in paralysis if not death as I no longer have the ligaments to absorb and buffer such a shock. My neck, held together with titanium and scar tissue, is strong but not as strong.

I am lucky in so many ways. I survived, but if I were in a wheelchair, I still would have survived. It's a miracle I can do the things I used to do. And because I could lose the ability to take part in so many simple activities, I try not to take them for granted. I have daily reminders of what I did lose. I can't run and my handwriting stinks. But this just reminds me again of what I can do: walk, paint, breathe, see, smell, taste, watch a cloud pass overhead, love, and almost most of all, work, which is most like love.

Terry Considine, a friend, broke his back riding his horse the weekend he declared his race for the U.S. Senate. He didn't let it stop him as he campaigned furiously from his bed at Craig. He lost that race but won another one—he walks. He used to visit me in the hospital almost daily. "So don't you feel as though you've been shot at and missed?" he'd ask.

Not missed, grazed.

ESSAY
Roxana Robinson

The tradition of portraiture is long and distinguished. Power has always been a part of this tradition, and, historically, portraitists have recorded various forms of it—political, economic, intellectual and erotic. There are monarchs: the stiff and elderly Elizabeth I, the shrewd and forceful Henry VIII, the arrogant Spanish royals. There are rich men and their wives: the kneeling patrons flanking Madonna and Child in early Netherlandish altarpieces, with their solemn, pious faces, their poses declaring humility, their presence proclaiming wealth. There are the great erotic presences: Sargent's fabulously disdainful Madame Gautreau, Manet's cool, commanding Olympia, Goya's languorous and inviting La Maja Desnuda. Political potency is embodied by the romantic image of Napoleon; formidable intellect by Picasso's Gertrude Stein; both erotic and intellectual power are present in Modigliani's melancholy Anna Ahkmatova. The presence of individual power distinguishes portraiture from figure study—the "Kneeling Nude," or "Standing Figure in a Landscape"—in which the formal challenge of painting supersedes the identity of the sitter. Power is that which attracts the painter to the subject, or, in a commissioned work, power drives the transaction. Working within the constraints of their idiom—delivering the likeness of a particular individual—portrait painters have always found ways to explore the aesthetic possibilities of their eras.

Hilary Cooper is a highly sophisticated artist whose work manifests a deep awareness of this distinguished tradition. Among the predecessors who have influenced her are the great Spanish portraitist and social realist Francisco Goya, and the powerful contemporary American portraitist Alice Neel, as well as contemporary realists like Joseph Santore, and the London painters Lucian Freud, Frank Auerbach, and Michael Andrews. All these share a powerful understanding of psychology and a passionate commitment to certain truths, and it is from this tradition that Cooper draws.

<center>* * *</center>

Hilary Cooper was born in 1958, in Germany, to American parents. Her father was in the Foreign Service, and the family was peripatetic, moving briefly to Yugoslavia and Pakistan, before settling in London for four years. Though Cooper was still a child at the time, these years in London were aesthetically important to her. The city, with its great museums and galleries, its great tradition of portraiture, became a powerful presence. "I first began to look at portraits there," she said. "I've always been drawn to people. I've always been interested in faces, in caricatures, in what it is that makes people identifiably themselves."

After four years in England, Cooper's family moved back to America, where she entered boarding school in Maryland with a full scholarship. The art teacher was the first person to encourage Cooper as an artist, urging her to do advanced work. Cooper thrived, graduating second in her class and accepting another (partial) scholarship to Mt. Holyoke. In college, however, Cooper chose to major in English literature instead of art. "It seemed more substantial," she said, "but I still knew I'd be an artist." After graduation, in 1980, Cooper moved to New York and looked for work. "I'd have liked to go on to graduate

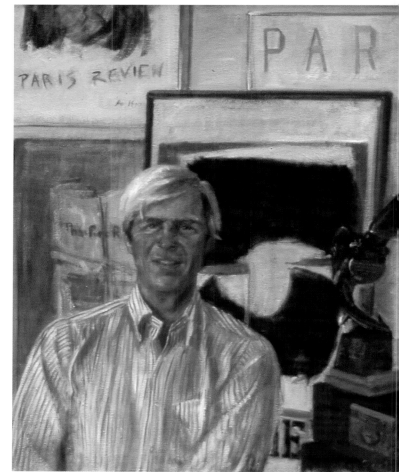

George Plimpton, oil on canvas, 38 x 30", 1987.

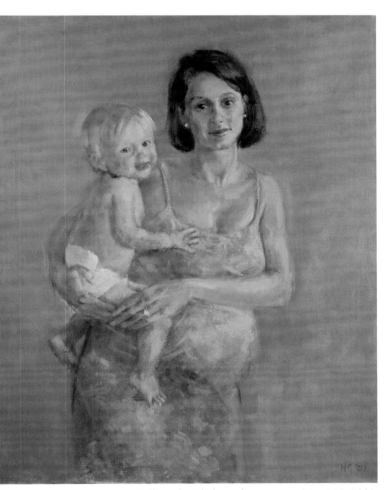

Holly and Nicholas, oil on canvas, 34 x 28", 2001.

school in art, but it wasn't an economic possibility." When a friend told her that banks were hiring English majors, "I was curious," Cooper said. "I wanted to know how the world worked." She was offered a job in a bank training program and took it: "It was either that or being a waitress." Cooper still knew she'd become an artist.

During the banking years, she continued her aesthetic education on her own, flying back periodically to London to see the current work. She was drawn to the figurative tradition, but this was unfashionable in America during the nineteen-eighties. In England, however, she found contemporary artists working within the tradition in a fresh and innovative manner: Lucian Freud, Frank Auerbach, and Michael Andrews. She went to see their work as often as she could. On one of her trips to London she met Lord Gowrie, a past Minister of Culture for Great Britain, and told him about her work. He responded encouragingly, "It's nice to know there are some guerilla figurative painters in New York."

In New York, still working as a banker during the day, she began a parallel life, taking evening classes at the Art Students' League. She spent all day in the office, wearing bankers' suits, but after work she headed for the studio. There she vanished into the ladies' room to change into the costume of her secret life: paint-splattered jeans. She studied with the realists—Burt Silverman, Harvey Dinnerstein, and Peter Cox.

In the late eighties, after seven years in the financial community, it was time to leave the office job. "I realized I had to become the person I was going to be," Cooper said, "and I wasn't a banker." It was then that she focused exclusively on art, and began taking classes full-time at the Art Students' League. "In the mornings we'd paint with artificial light, and in the afternoons in north-facing light, natural light." On the weekends she painted on her own, in her studio. "I painted all day long, every day. I was putting miles on the brush."

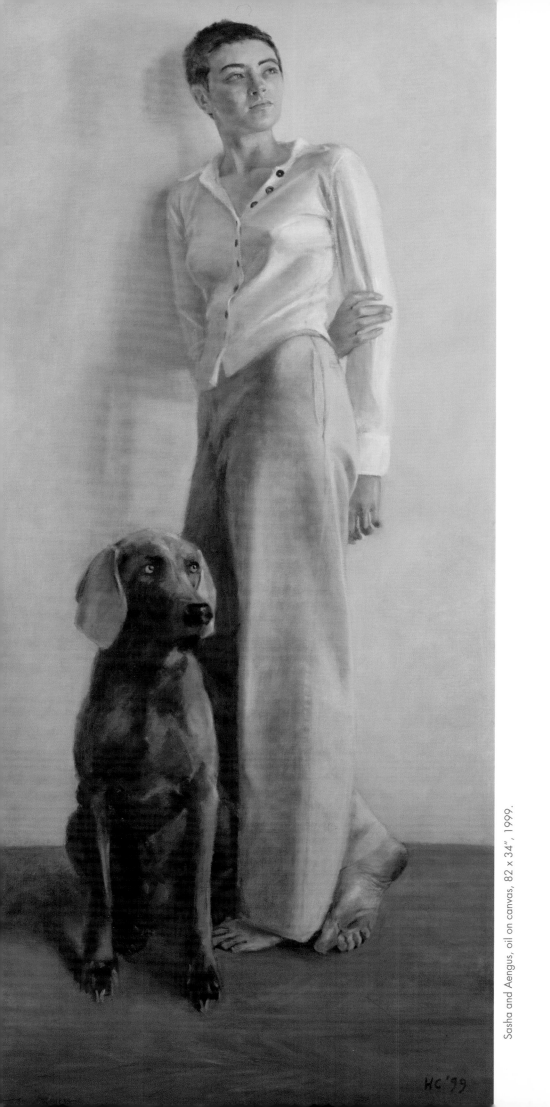

Sasha and Aengus, oil on canvas, 82 x 34″, 1999.

HC '99

In 1991, at a Whitney Biennial, Cooper first encountered the work of the figurative artist Joseph Santore. "Like Lucien Freud, he was, for me, a revelation. Both a figurative and contemporary painter, he could really handle and used a ton of paint. So many contemporary painters were flat or photo realists." It was a transformative moment, in which Cooper realized that it was possible to be both a part of the figurative and contemporary currents. She was not interested in simply reproducing the glories of the past, but wanted an innovative response to tradition.

The next step in her education occurred when she encountered Leonid Lerman, the Russian sculptor. "He taught me to sculpt. He also pointed out how much I didn't know, how much I relied on my eyes. He taught me to understand structural anatomy so that my art would not be haunted by the lack of understanding. Know it, then forget it, so expression can happen."

Since then, Cooper has continued to work, expanding the notion of the realistic figurative tradition. She has become a well-known portrait painter, because of her skilful technique, her empathetic response to her sitters, and her uncanny ability to capture a likeness. She has painted New York Mayor Ed Koch, writer Peter Mattheissen, the late *Paris Review* editor and impresario George Plimpton, among other figures in the worlds of culture, politics, and society. There is more, however, to Cooper's work than technical skill: she is making a powerful addition to the tradition of portrait painting.

<p style="text-align:center">* * *</p>

Cooper's painting style is impressionistic, her brushstroke loose. Her palette is muted and her colors soft. The presence of light is both a defining and a dissolving force; shapes and forms are molded through broad strokes of shadow and radiance. A master of likenesses, she is deeply attentive to gesture, posture, and expression as elements of the representation of self—though she does not limit herself to portraiture, and works as well in the genres of landscapes and still life. She has a formidable grasp of composition, and is highly skilled at surface and texture: the rendering of the smooth, silky head of a grave-eyed weimaraner is one of the exquisite moments in the many offered by her work. Working within the strong disciplines of the realist figurative tradition, her technical skills are considerable and impressive. It is her intention, however, rather than her technique, that is radical.

Hilary Cooper has produced a suite of portraits whose power is complex, unexpected, and deeply unsettling. In this group, Cooper presents sitters who are full of energy, strength, and beauty—all those powers that portraits traditionally record. In fact, these sitters might easily be contemporary monarchs, merchant princes, and famous beauties, since, today, the powerful people are no longer easily identified by pose and dress and accoutrements, as they once were. But pose and dress and accoutrements continue to inform us as to rank, status, wealth, and capabilities.

Cooper is particularly aware of these attributes, of the way the body informs us of the sitter's life. After suffering a devastating, and nearly fatal, fall in 1996, Cooper temporarily lost the use of her limbs. Involuntarily, terrifyingly, she became a member of a new community. This was one which had always been adjacent to the one in which she'd lived, but it had been nearly invisible to her: it was the community of people who do not walk, who cannot command their bodies. These are people who deal—every second of their lives—with a set of problems other people do not confront.

As a new member, Cooper examined this community with great intensity. Acutely aware of the individuals who make it up, she began to examine them as personalities, as characters and presences. She began to see them as

subjects of her art. In doing so, Cooper has produced portraits that present a new and complex posing of the mind-body problem. What is the true relationship between mind and body? Which of them is the most profoundly defining force? In what ways should we consider a person? What assumptions do we make in our consideration? Why do we make such assumptions? What will make us change them?

<div align="center">

* * *

</div>

Cooper presents these sitters in a bold and arresting manner, using two separate but related images. The two paired canvases, hung near each other, offer wholly disparate views of the same subject. Our gaze is drawn first to the upper canvas, which contains The Face. Here, the sitter's head informs us of vitality, intelligence, beauty—all the possibilities of power that the human presence can offer. These faces are alight with all those powers that portraits traditionally record. Cooper's rendering is skillful and authoritative, and in it she asserts what we know to be true: here is the life of the sitter. Here is the powerful presence, here is the life force that animates the person.

It is the second image, set lower down and often smaller, often blurred and indistinct, that creates the work's unsettling discordance. This second canvas informs us of another aspect of the sitter's life—physical vulnerability and loss. Cooper's rendering of the wheelchair—the Chair, as she calls it—is separate and subordinate as an image, but even in its separate and diminished state we understand how powerful it is, how necessary it has become in the lives of the subjects. Both an emblem of helplessness and vehicle of possibility, it reminds us of how adamantly the body controls our lives. It is the troubling juxtaposition of the two images that commands our deepest attention. Our glance moves back and forth between the two images: here is

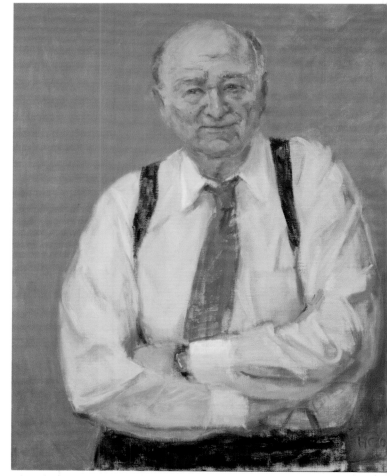

Ed Koch, oil on canvas, 34 x 28", 2003.

the charged and forceful vitality of the head; here, the poignantly diminished presence of the body. The painful pairing of vigor with its absolute absence requires (like poetry) a pause, an interior silence, a hushed remarshalling of our comprehension.

These powerful images, full of challenge and energy, acceptance and loss, rendered in her soft, muted, painterly style, are full of surprisingly radical intentions. This work does what all new art does: it asks us to question our assumptions, to reorder our hierarchies, to recognize the presence of something unknown.

In these beautiful, dangerous portraits by Hilary Cooper, The Chair reminds us how powerful is the life of the body. But it is The Face—charged, proud, beautiful, triumphant—that demonstrates how unassailably superior is the life of the spirit. Cooper's greatest offering lies in the humanity which informs this group of paintings. Her art is generous, visionary, and compassionate. In these brave images she reminds us of how much we owe to the life of the spirit, how marvelous is its presence, and that it is here, within the soul, where we really live.

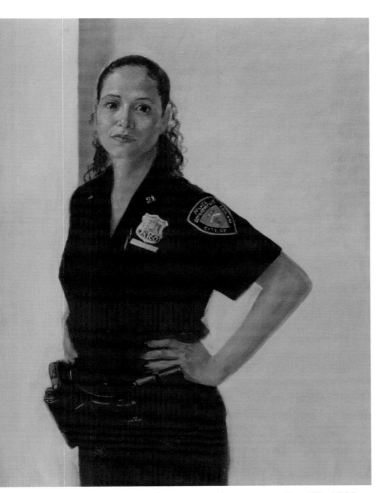

Policewoman, oil on canvas, 48 x 37", 1999.

PLATES

Katie Labahn is twenty-three and she has had to cope all her life. Cerebral palsy starts at birth and never quits, for a single day. I met her when I saw her crossing a busy street downtown in a chair. I was struck by her remarkable, child-like beauty. I just introduced myself, told her about this painting project and in an instant we were talking. She agreed to sit for me and we've been friends since. Early on, she decided that she would become an actress. She got into a decent college and studied acting, then came to New York to pursue her career—first in the NYU summer acting program and then she landed a rare spot in the Neighborhood Playhouse. It was not a slot for the disabled—just a slot.

Katie goes on casting calls all the time. Not casting calls for girls in chairs, just regular casting calls. For soaps and the like. You know the kind of thing: a kid assistant-director comes out and says to 200 hundred young women, "All right, all you brunettes take a step forward." Pause. "Okay, you can go home because we want blondes for this one."

KATIE LABAHN

The brunettes go home. General casting calls are brutal and Katie is very rarely chosen. But she likes to go for two reasons. One, she is ferociously asserting her common humanity. And, two, she likes to make the bastards look her in the eye when they say, in effect, "Sorry, no cripples for this one." And sometimes she gets a job, to the surprise of everyone involved. And she does well, because she is good.

I introduced her to Krista Smith, head of the Visible Theater, and Krista got it right away. So you may see Katie in some of Krista's amazing productions. If you do, you'll be lucky. She is terrific, and she gives some of the most moving performances in what are always deeply moving productions.

Oil on canvas, 24 x 20", 2003. Opposite, oil on canvas, 36 x 44", 2003.

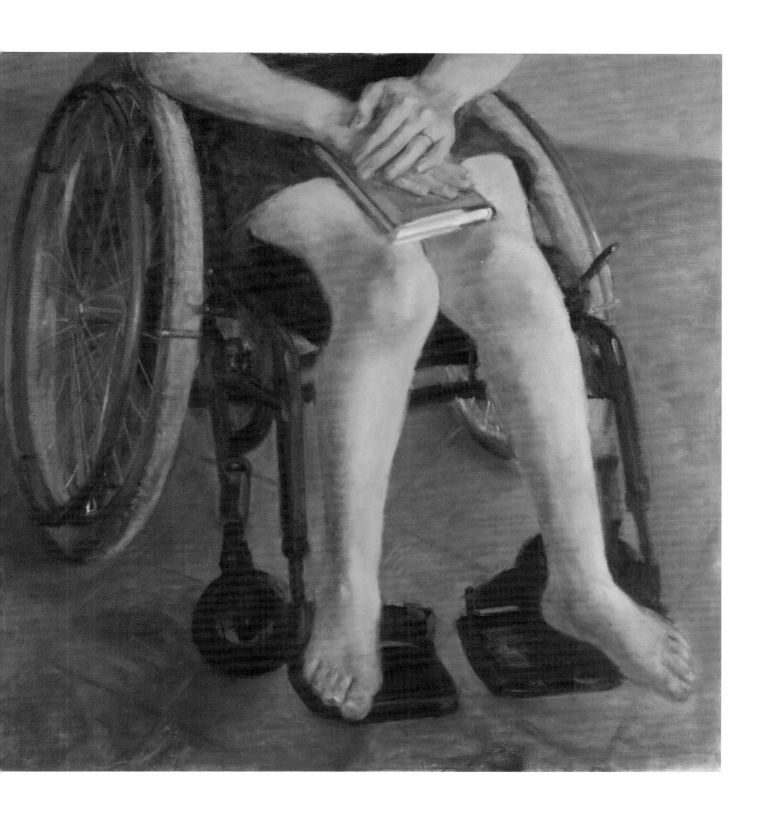

PARKIE
SHAW

Parkie Shaw and I became friends almost twenty years ago. In those days he was an elegant, imposing figure with a sharp wit and a strong sense of his New England roots. He occasionally affected a cane because, he said, he was in the early stages of a disease the name of which did not sink in. It was multiple sclerosis. It has sunk in.

Today, he cannot walk and all movement is extremely difficult. His sense of humor and his remarkable intelligence survive, but he is much kinder now and he more often jokes about himself. "I am an expert on belt buckles," he says, "and I can recognize people by their nose hair. At four-six one sees life differently than one does at five-eleven. Quite an interesting change."

He is still a commanding figure, sometimes literally. At parties and so on, when he is being ignored, as people in chairs often are, he simply summons an interesting person to his side and starts talking, as he always did. And listening too, as he does now.

He says this about his disease, which he has thought about in depth. "MS is a relationship. It is not your friend and it is not your enemy but rather it is your constant companion. You have to make time for it as it will certainly make time for you."

I had always thought he was a good guy, even when his manner was a little imposing. Now his life is difficult, very difficult indeed. And his response to it is as elegant as anything he has ever done.

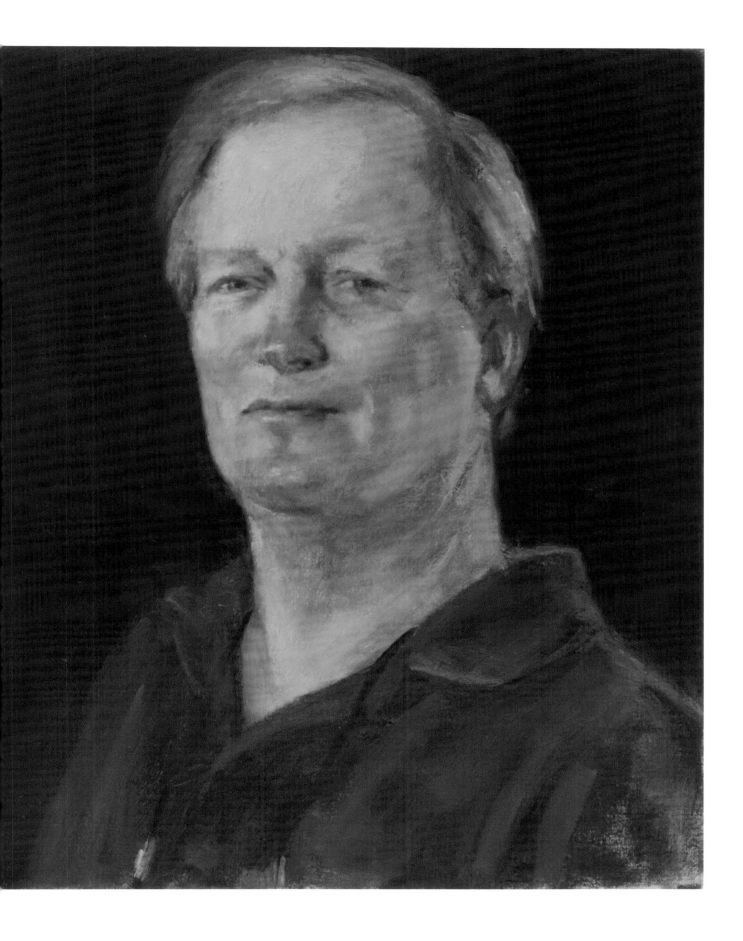

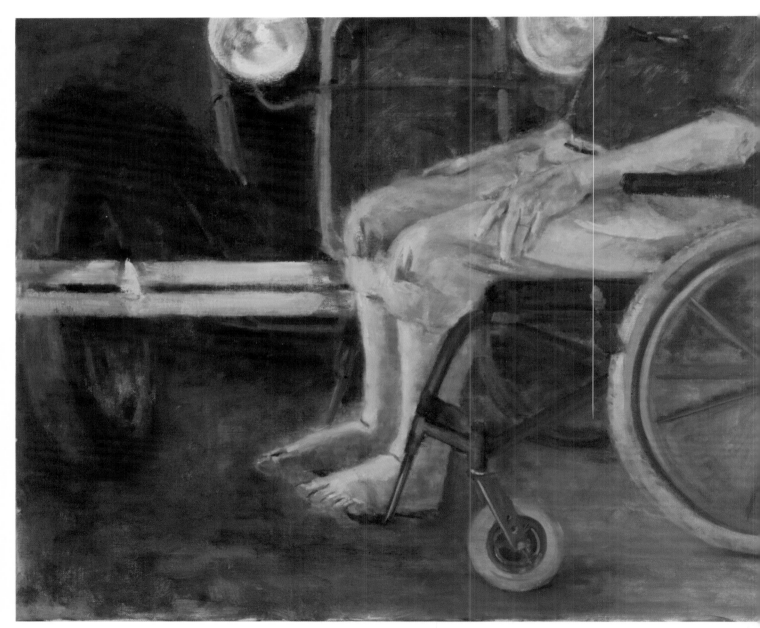

Opposite, oil on canvas, 18 x 16", 2002. Oil on canvas, 34 x 42", 2002.

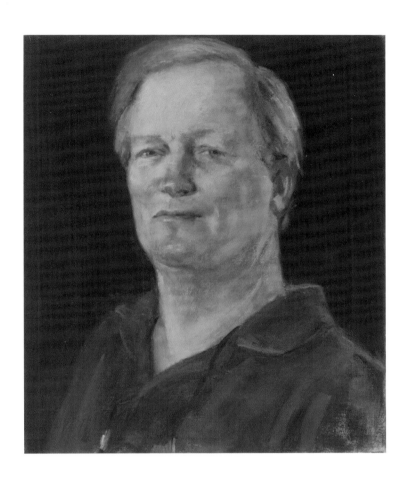

ARDEN
LEE

Arden was seven when I painted her in 2002. She has Spinal Muscular Atrophy (SMA), a degenerative disease similar to Lou Gehrig's but which affects children. She is smart in school and lively and a total kid. Arden lives a very full life. Despite her SMA and a wheelchair, Arden takes karate, rock climbing, swimming, and art and music classes. She has travelled extensively up and down the East and West coasts and her next destination is hopefully the Four Corners (of Colorado, Utah, Arizona and Nevada). Painting children is one of the hardest things to do and Arden was no exception. She squirmed and demanded that all her favorite books be read to her. At the breaks she'd be lifted to the floor so she could play with her enormous cache of Barbie dolls. Her Barbies had many outfits and sets including a disco, a pony, and naturally enough, a wheelchair. Today, Arden has outgrown the dolls and is a typical "tween" who looks at her divided portrait and explains that she was chosen to sit because she is *special*.

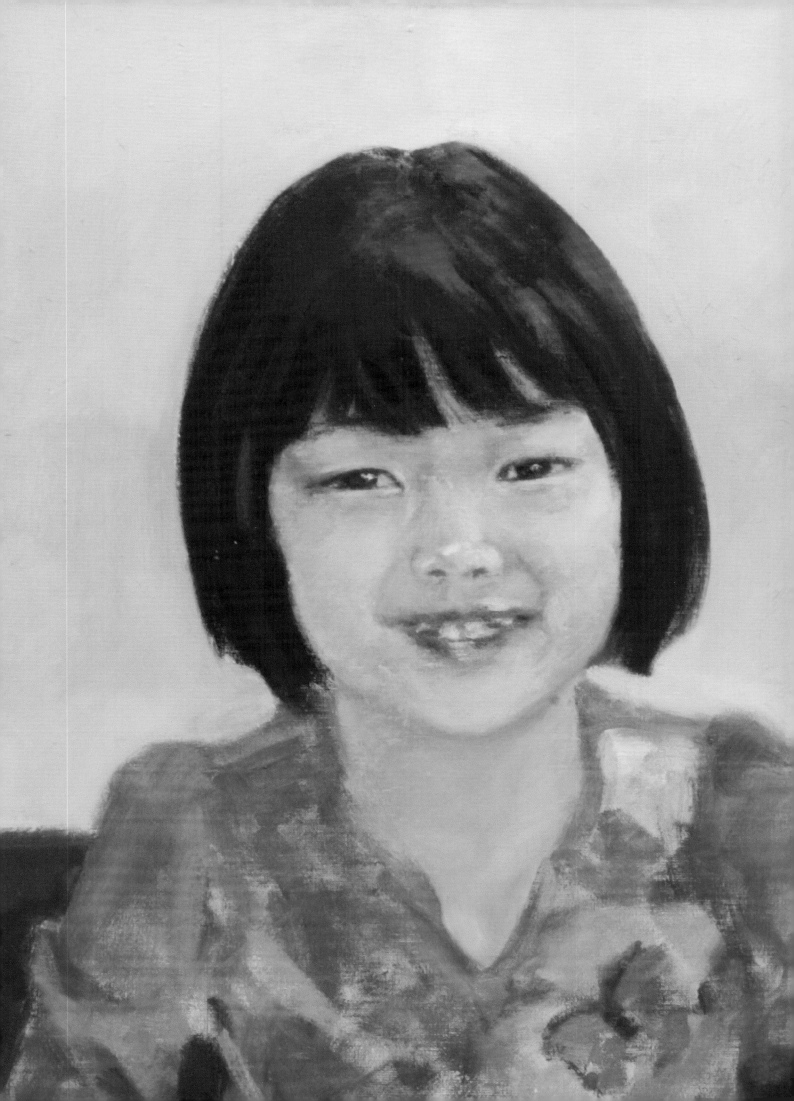

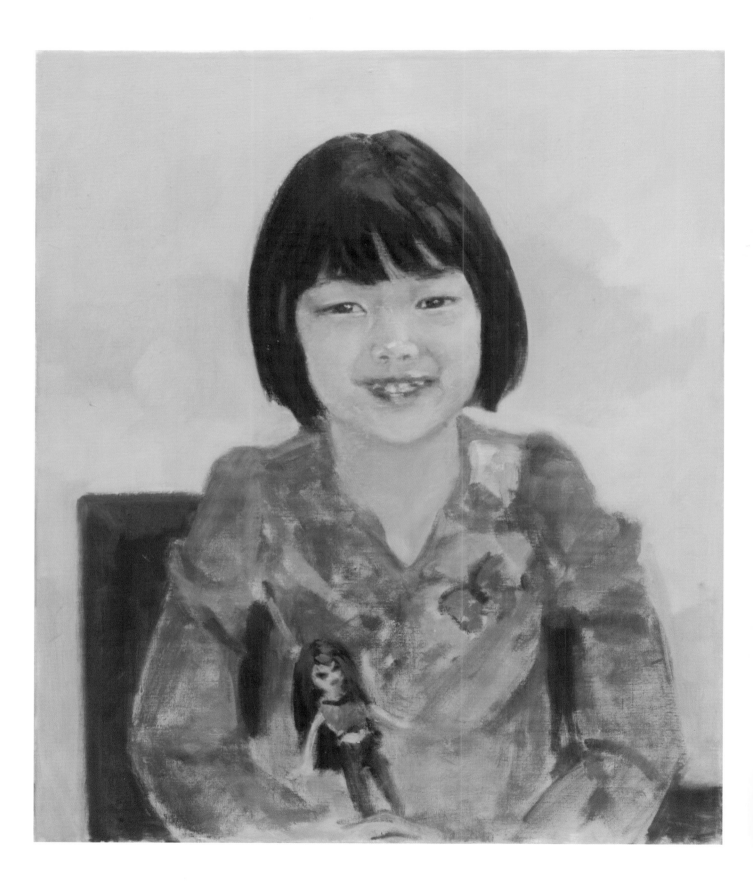

Oil on canvas, 25 x 21", 2003. Opposite, oil on canvas, 25 x 21", 2003.

JIMMIE
HEUGA

Jimmie Heuga became a national hero forty years ago when he and Billy Kidd became the first Americans to win Olympic medals in alpine skiing. I know that because among the many teenage boys who idolized him back then was a passionate skier named Steve Johnson. Johnson became an excellent ski-racer and an even better neurosurgeon. And eight years ago, he and a spine surgeon named Alec Jones worked together for ten hours to put my neck back together after I fell down a steep flight of stairs in an unfamiliar house and broke it so badly that I seemed almost certain to be a near-complete quadriplegic. I am not, and now Steve, who is not the type, is one of my heroes. It was at his suggestion that I painted Jimmie Heuga with whom I had something in common. For different reasons, he too had wound up in a wheel chair, and he is still there. For a lot of people, certainly including me, Jimmie Heuga is a hero today for the way he has risen to that life-long challenge.

Multiple Sclerosis—which is what put Jimmie in the chair—is a one-way, life-long trip into deepening disability. Jimmie was diagnosed in 1970 and has gone from being an Olympic athlete to living in an assisted living center in Colorado. He has fought the disability like a lion the whole way. He created The Heuga Center which provides support for MS victims. It is a great success and, for many today, it defines Jimmie Heuga as much as that Olympic medal forty years ago. In his own life, he has worked hard to stay connected with his body by doing as much exercise as possible, for as long as possible. Then falling back to the next level and starting again. He is a model to thousands with the disease.

I painted Jimmie in that assisted living community and watched his daily routine with deep admiration. He's up by 5, dressed, showered and shaved, choosing to be attended to by the night staff rather than an already overburdened morning shift. Then he goes about his exercise and other routines. I would get there around ten and he would sit for three of four hours. In those long sessions, his energy, his crackling enthusiasm and his lovely sense of humor never waned, never faltered. His handsome French/Basque looks and all that life in his face made him a joy to paint.

Steve Johnson regularly joined us for supper and Jimmie enjoyed the in-depth conversation about downhill racing and the minutiae of what went on forty years ago. But he does not want to live in the past. He prefers to talk about his three wonderful boys—the lights of his life—and his own occasional turn on a sit-down bi-ski. His body is slowly caving in but his spirit has not given an inch. It is a joy to be around him. He learned to be a hero all those years ago, and he is still hard at it.

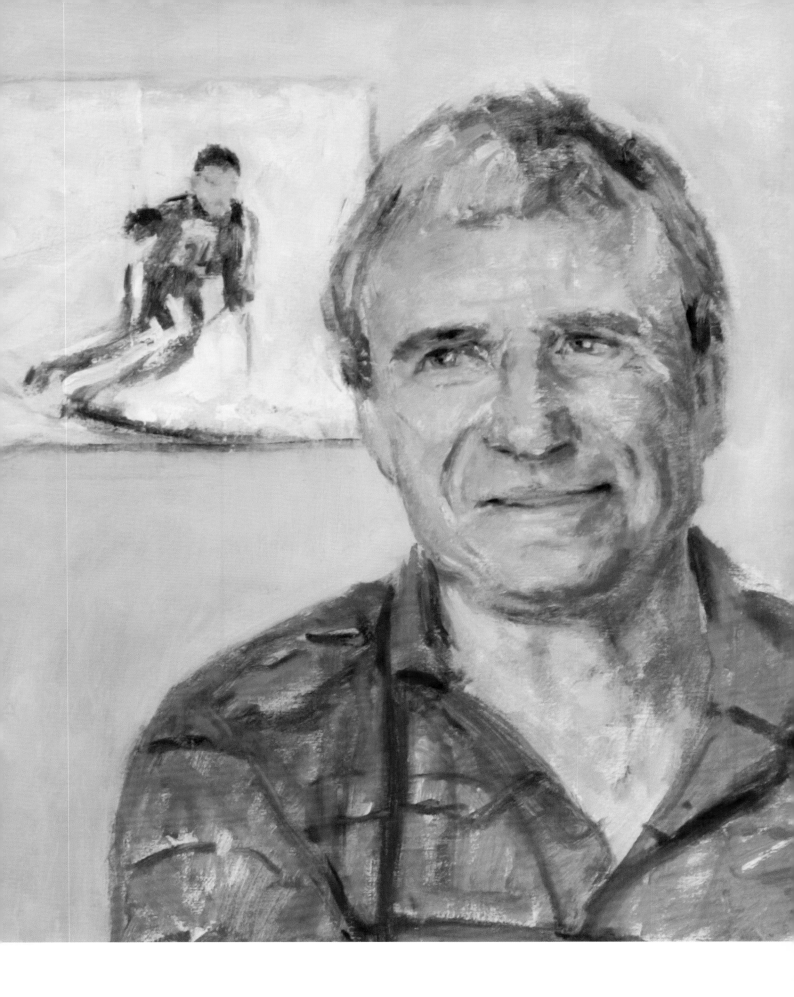

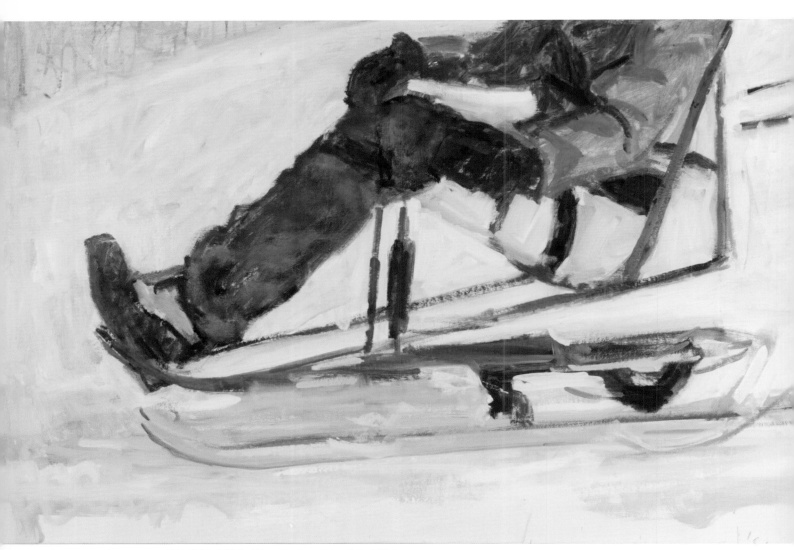

Opposite, oil on canvas, 24 x 28", 2005. Oil on canvas, 36 x 44", 2005.

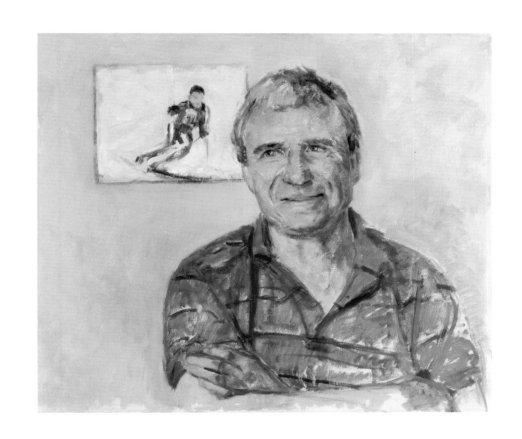

Jean Angell has always been a smart, able woman with great discipline and drive. A lawyer, philanthropist, a member of a long list of important boards of directors, she has raised an impressive family and lived an impressive life. At the age of 56 she got Lou Gehrig's disease. Her response was in character. She wanted, she said, to live her life as fully as she could, for as long as she could. She set about it with familiar intelligence and resolve.

Lou Gehrig's is a brutal disease—a remorseless slide into debilitation and death. I painted this divided portrait in 2001 when Jean could still operate her own wheel chair and talk and entertain in her airy, West Side apartment. Scheduling time with her was a trick because her life was still so amazingly full—of family, of friends and of professional commitments. I marveled

JEAN
ANGELL

at her energy and good humor. Among other things, she has more friends than almost anyone I know and she works hard at making time for them. They gladly make time for her. The disease marches along. When conversation got really hard for her, she scheduled "movie nights" when close pals would come over to watch videos. Not much talking, just being together.

Now she cannot speak and has to communicate by looking through and at a screen of words. Long after most people have given up—the patient gets to decide with this disease—she holds on to life, so as to be there for her family. Job's torments pale, and she never expressed a word of self pity or regret. She lives as hard as she can and she has done so all her life. She is an icon in this already elegant company.

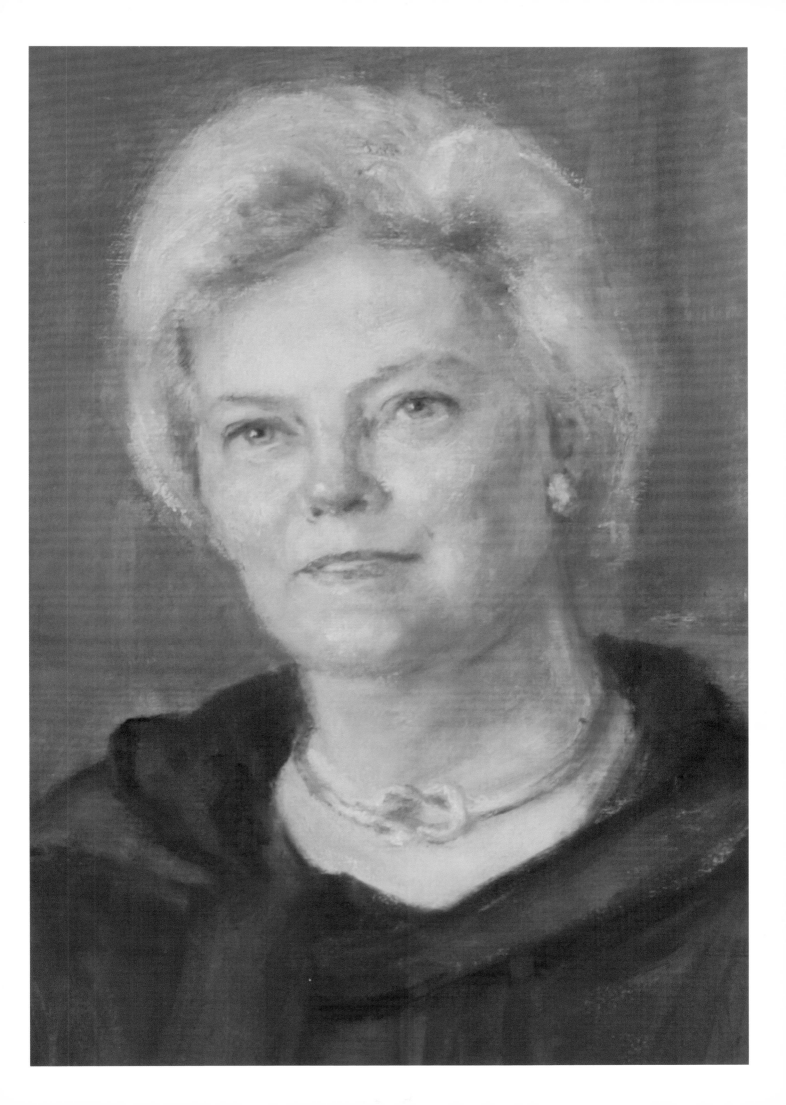

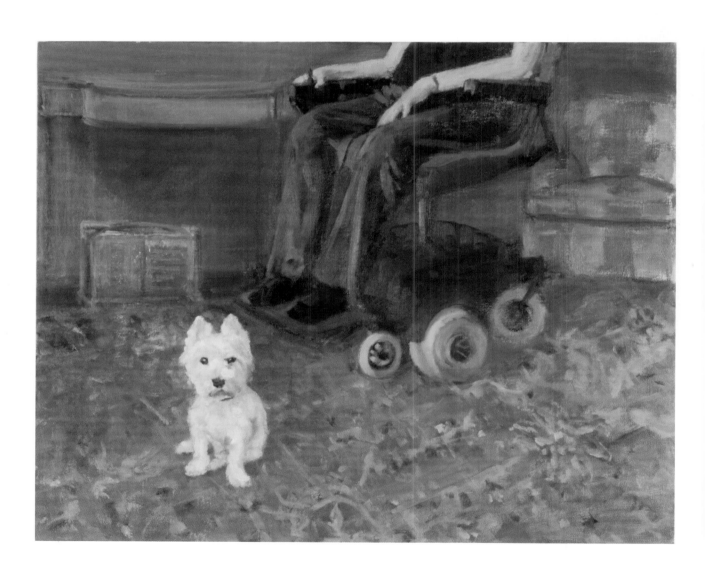

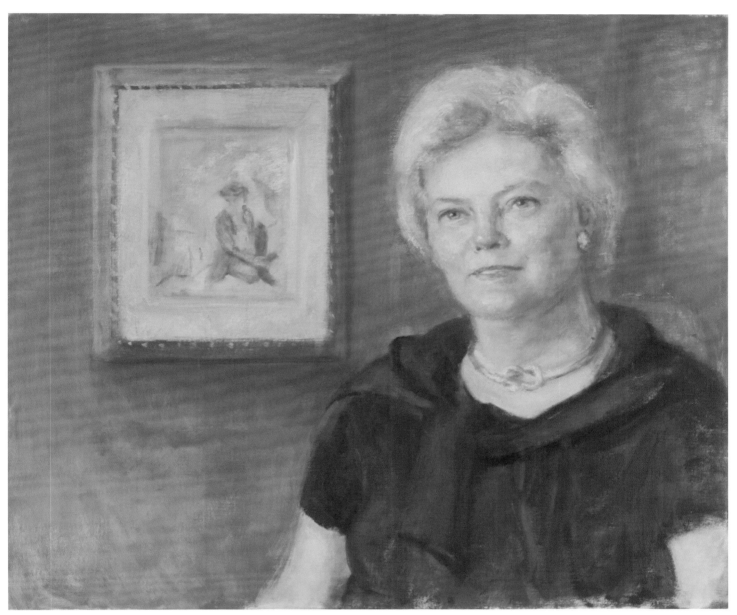

Oil on canvas, 20 x 24", 2002-2003. Opposite, oil on canvas, 16 x 20", 2003.

DENNIS
MURRAY

Dennis Murray is one of the lords of creation in Aspen. In Aspen, the real lords of creation are not the billionaires with 25,000 square-foot houses and revolving starlets with implausible breasts. They are the bartenders and dry-wall guys who can actually ski the powder and whose life is mostly lived outside those little strings that mark the out-of-bounds areas on Ajax and Highlands and beyond. Dennis Murray has skied it all. He has skied places that barely hold snow. He has pointed out "runs" on The Maroon Bells that made me feel queezy, sitting in the car. He is way strong, a stranger to fear and a ton of fun to be with. He is all smile and heart, and women find him attractive.

One afternoon, after a major day in the back country, he was skiing an ordinary traverse on an ordinary trail at Jackson Hole on the way to the parking lot. He caught an edge—went out of control for a moment. And found his tree.

He was instantly paralyzed and almost suffocated in the powder in which he fell. Luckily, someone found him in time and he was rushed to the hospital. The only damage was to his lower spine. He has the use of his hands and upper body but he cannot walk or ski conventionally. His hundreds of pals in town raised a surprising amount of money to help out, he has a job with the City, and he and his girlfriend, Lisa, have a terrific employee-housing unit at the base of Ajax. Which he cannot ski in, ski out of.

Actually, that's not quite right. He has taught himself to ski on one of those sit-down mono-skis that you steer with your body and with little skis on your hands, like outriggers on a canoe. He is terrifyingly competent on it, and a real challenge to normal skiers who try to keep up with him. He doesn't go out of bounds any more. But we were at a wedding together this summer, high on the back of Ajax mountain—out-of-bounds country. He was looking down at it speculatively from his wheel chair, which he powers over the rocks and grass by hand like a truck. He was looking down with a funny little smile that his friends would recognize from years ago. As if to say, 'maybe this winter'. He is still all smile and heart and a ton of fun to be with.

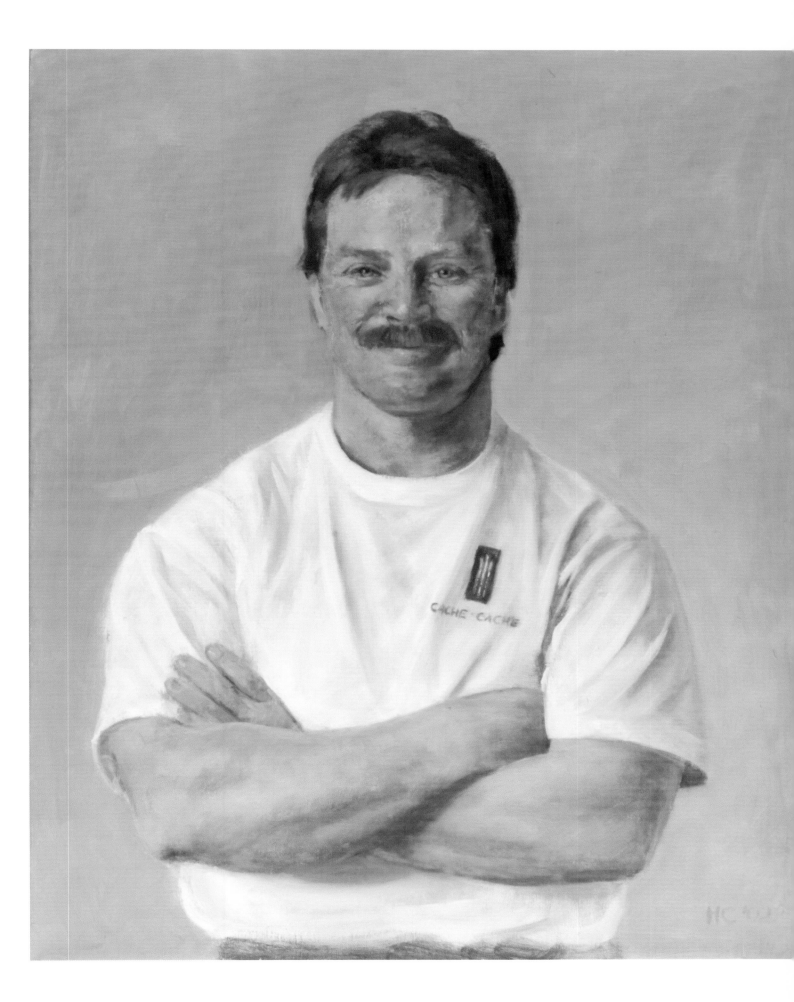

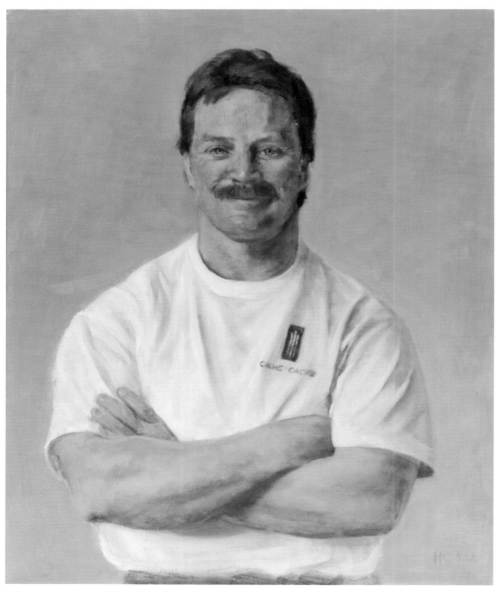

Oil on canvas, 34 x 28", 2003. Opposite, oil on canvas, 24 x 52", 2003.

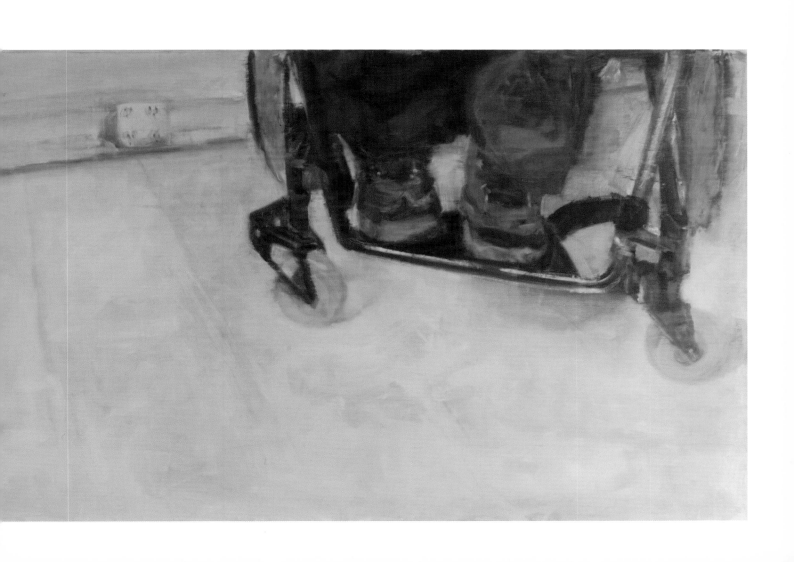

Amanda Boxtel came to Aspen from Australia seventeen years ago to "follow her heart." She stood five seven, blond, an amazing skier and amazing looking. She is also incredibly kind and smart and optimistic. She sits now because at noon (crack of noon club) she took her first run of the day. She had stuff on her mind, she told me as I painted her. "I had a hunch I shouldn't be there. I was really on edge. But I ignored it. I didn't know myself well enough then to understand that I have an uncanny ability to sense things."

She continued, "I was just about to start down and was so agitated that another skier actually stopped to ask whether I was OK. I said I was, even though I knew I wasn't but started my descent anyway, whereupon I simply crossed my tips, somersaulted, and landed hard on my low back."

"There was something like an electric shock through my legs, then nothing."

Nothing except the struggle to rebuild her life in terrific ways. Amanda is a teacher by training and temperament. Along with her colleague Houston Cowan, she created Challenge Aspen, a program that gets children and adults with all kinds of physical and mental disabilities into the hills to pursue a broad range of sporting and cultural activities.

AMANDA BOXTEL

I heard about Amanda when I was lying in bed paralyzed from the neck down. We shared the same PT, Conny McClintock, who insisted we meet. We did and became fast friends. She was the first person I wanted to paint when I conceived this project—and one of the last to finally pin down. I literally spent one two-month stretch in Aspen pleading with her to find time to pose.

"I really want to, Hilary, and I'm so sorry but I'm leaving on a trip to Antarctica this week and then there are the Paralympics."

There was nothing for it but to get her to New York, which she did squeezing me in between Broadway shows. I was inspired to paint her nude because she is just so beautiful, particularly her torso. (Only her legs are paralyzed so her torso, her core, is amazingly strong.) Bonnard's bathers came to mind and inspired me to paint Amanda using that convention of the *beigneuse.* I also mimicked his use of bright color. Ironically, Bonnard's model, his wife, Marthe, was quite disabled emotionally and spent a great deal of time taking baths. By contrast, though in a wheelchair into which she is "transferring," Amanda, is anything but. Yes, she sits, but she does not sit still and she is all heart.

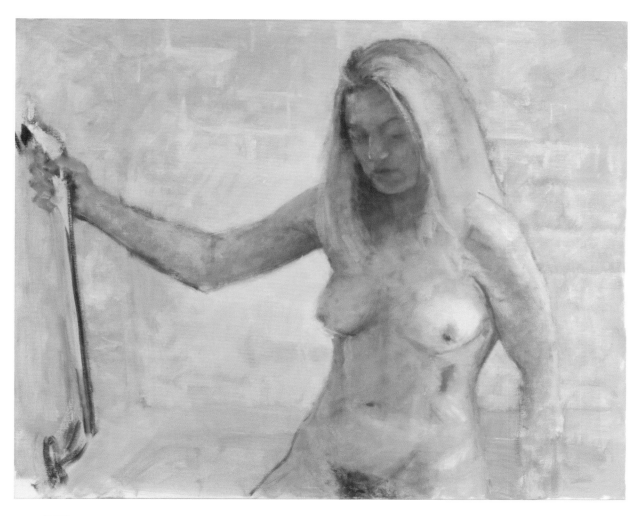

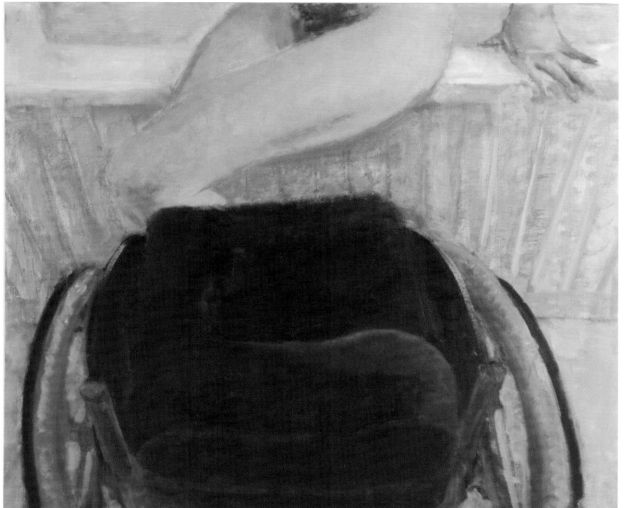

Oil on canvas, 35 x 42", 2003. Oil on canvas, 36 x 44", 2003.

Liz Treston is one of the coolest women I know. She is a speech pathologist by training, but wears many hats. Funny and very smart, people want her to run things. Like TRAID, a company which provides Technology Related Assistance to People with Disabilities. She said she'd run the program for a year. That was ten years ago.

She also gets into the schools to build awareness for disabilities. She'd just been there the day before I was to paint her, with Nello her canine companion. She recounted her day to me and it was entertaining.

Fourth Grade:

"Can I have a volunteer?" and before anyone consents she's volunteered the squirmiest kid, who has been paying the least attention. He is stunned to find himself before his classmates, sitting in a wheelchair with a pencil in his hand, which Liz has supplied him.

"OK. How'd you get there?"

"Uhhh."

"Was it a disease or from birth or an accident? What?" The rest of the class is getting into it. "An accident!" they offer. So now they're learning that there are lots of ways to wind up in a wheelchair.

"Great." She knocks the pencil out of the kid's hand. "Now pick it up." He gets up. "Uh uh uh. You can't walk."

LIZ
TRESTON

"Oh I forgot."

"So how are you going to get it?" A blank.

"The DOG, the DOG!" the other kids are yelling.

And so Nello quietly gets up retrieves the pencil hands it to the kid and returns. Pretty cool. And the kids are totally intrigued. And often recognize Liz around town and far from being shy about a person in a wheelchair, run up and say hi.

Liz, herself, dove into a swimming pool at nineteen and was paralyzed from the neck down. Not a dumb shallow end thing. She was an excellent competitive swimmer and diver. It was one of those pools, long since outlawed, where the grade from the deep end to the shallow end is so sharp that it's like a wall. One that she slammed in to and started her second life as she calls it. Her second birthday. She is twenty-five.

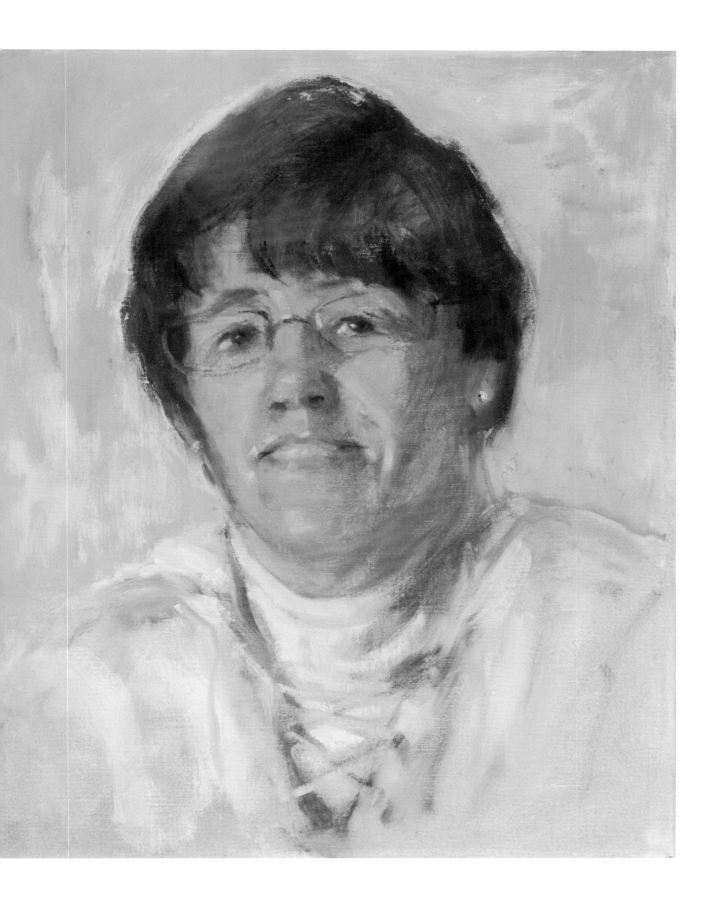

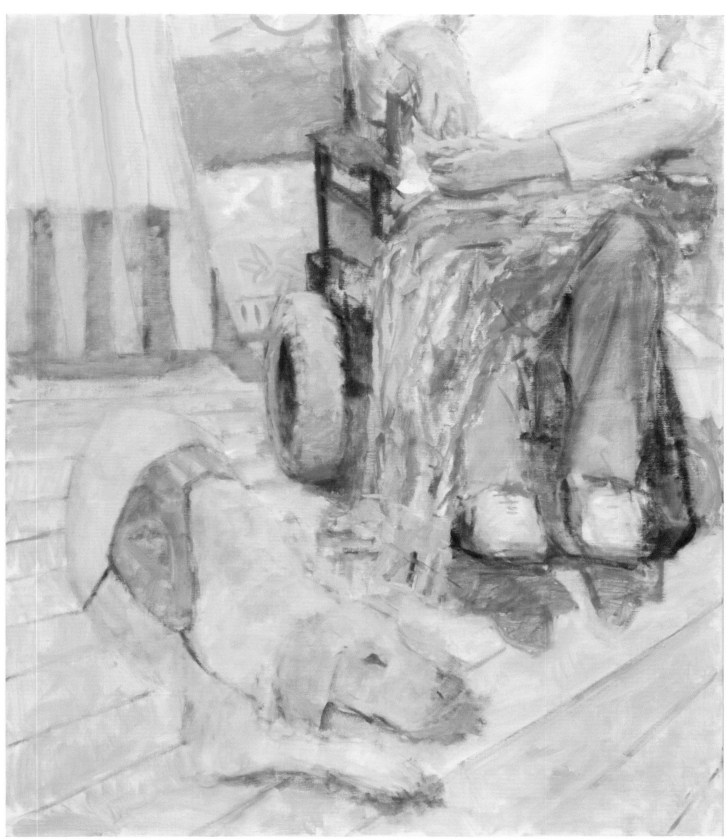

Opposite, oil on canvas, 18 x 16", 2004. Oil on canvas, 42 x 34", 2004.

JOE SIMS

Joe Sims is a journalist, a political activist and a writer. He is also a powerful and talented actor, which is how I got to know him. He was in the Visible Theater "True Story Project," one of a group of serious actors who write and then perform monologues which are woven together as a remarkable ensemble piece. Joe's performance was transcendent.

I got to know him some—persuaded him to sit for the sculpture you see here. Over time, I learned that he is a serious thinker. He is the editor in chief of "Political Affairs," a Marxist monthly (not so many of those around these days) and he feels passionately about a range of political and social issues.

He comes by his views—and his passion—honestly. Born in Youngstown, Ohio, he was hugely influenced by his family—steel workers and union men and women. His grandmother helped found the United Steel Workers Union in the Thirties and was also active in the African American Freedom Movement and the NAACP. His father ran for Union President.

Joe became an actor when the fledgling troop held a rehearsal in the lobby of his apartment building. One of the actors noticed his curiosity and dared him to join in. He did. "I was taken in by what they were doing—the process of story telling. I've been there ever since." His stories are magical and his performances commanding in part because he uses the full range of his physicality including the aids he needs as a result of being born with Spina Bifida. He may start in a chair, descend to the floor, reach for a crutch to stand up. It is almost a dance without ever being a distraction from the tale he tells. And it is beautiful.

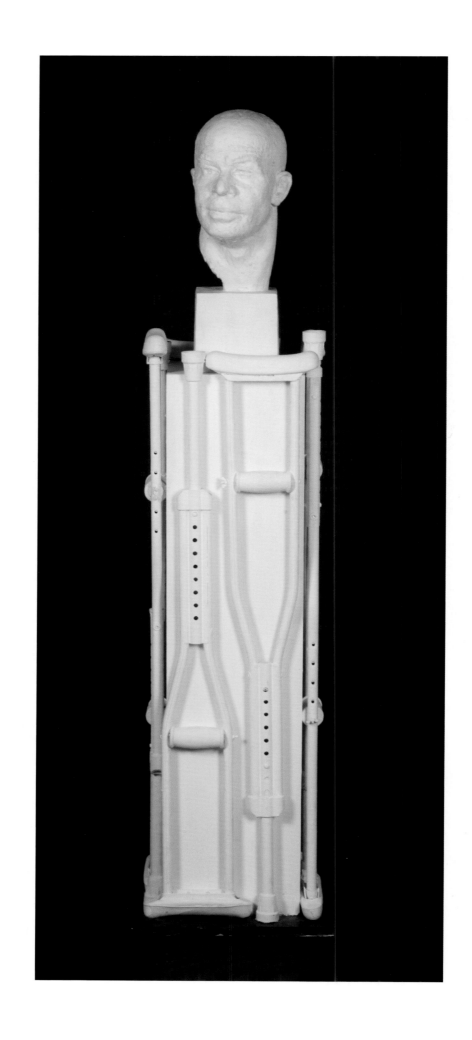

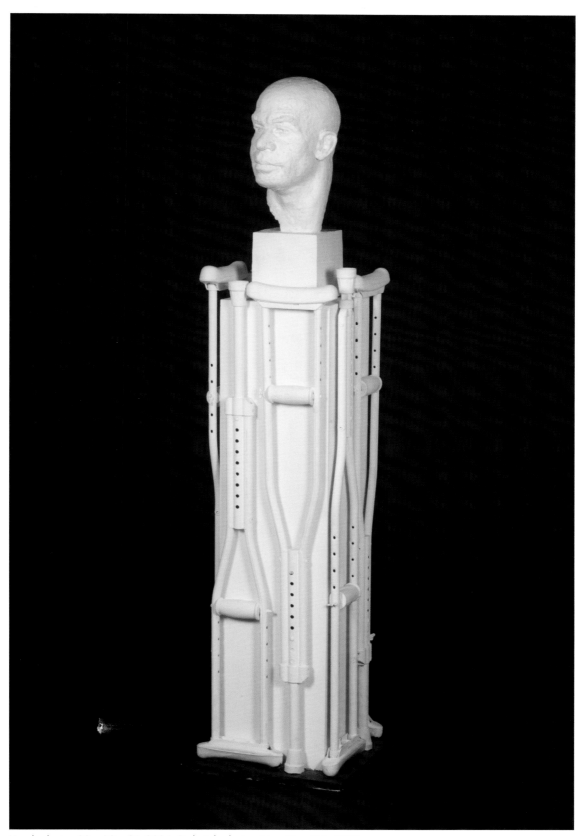

Head: plaster, 22 x 10 x 8", 2004. Pedestal: plaster, 16 x 16 x 46", 2004.

On sight, it is clear that Staff Sergeant Heath Calhoun is a very decent guy, and a very good soldier. It is in his face, in the way he carries himself…everything. It could be argued that he was born to it, like his father (Vietnam) and grandfather (WWII) before him. And probably like his son Mason, four, who already spends a lot of the time in the soldier suit he got for Halloween. A surprising number of America's best fighting men have always been Scotch Irish, like Calhoun, and an awful lot of them have come from southern hill towns like Bristol, Tennessee where he grew up. Anyhow, it's clear that, if you were in a jam, you would be plenty lucky to have Heath Calhoun at your side, or at your back.

He still conveys that sense, powerfully, even though both his legs were blown off, above the knee, in Iraq in 2003 by a rocket-propelled grenade. These days, he is fighting—calmly, quietly and with ferocious resolve—to create a life for himself and for his wife and three kids, two born since his return. A couple of mile-posts: he learned to mono-ski, hard and fast, just five months after he was injured. And he rode 4,200 miles across the country, on a special bike that you pedal with your arms, to raise awareness and money for injured veterans. He is also a national spokesman for the Wounded Warrior Project, a group that lobbies for wounded soldiers, and he regularly counsels the newly injured.

HEATH CALHOUN

But his great passion these days is to walk. He tells me that people who lose both legs above the knee do not walk, and, when we met, he said that he had resigned himself to being in a chair from here on out. But there is a prosthetic leg maker who is experimenting with a computerized prosthesis that may change that. They chose Heath as one of two men to be "on point" for the effort. Good choice.

Heath's sense of urgency about the prosthesis and walking is interesting, in the context of this project. He says what all the people I have painted here say: that being in a chair is profoundly different and that people see you differently…discount you in some way. If it is humanly possible, he wants to meet the world at eye-level. If not, he will do what he must and, it seems clear, he will do it brilliantly. Like everyone else in this project, it would be quite a mistake to discount Heath Calhoun. At any level.

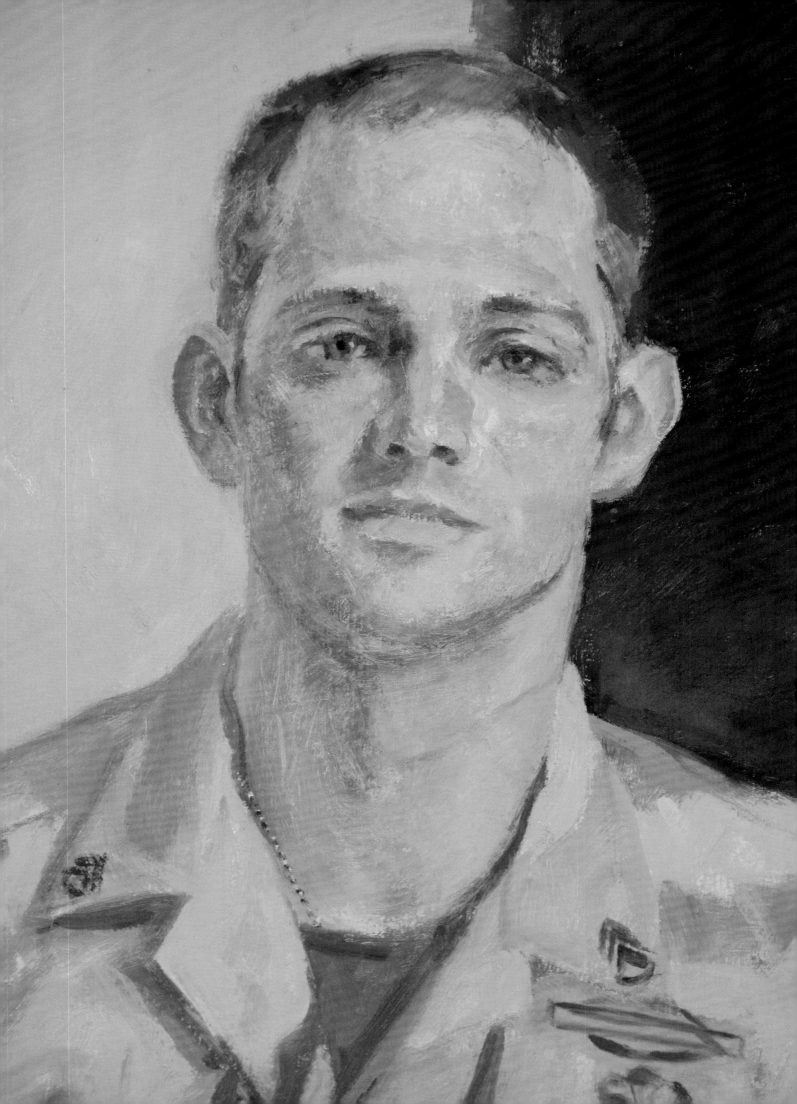

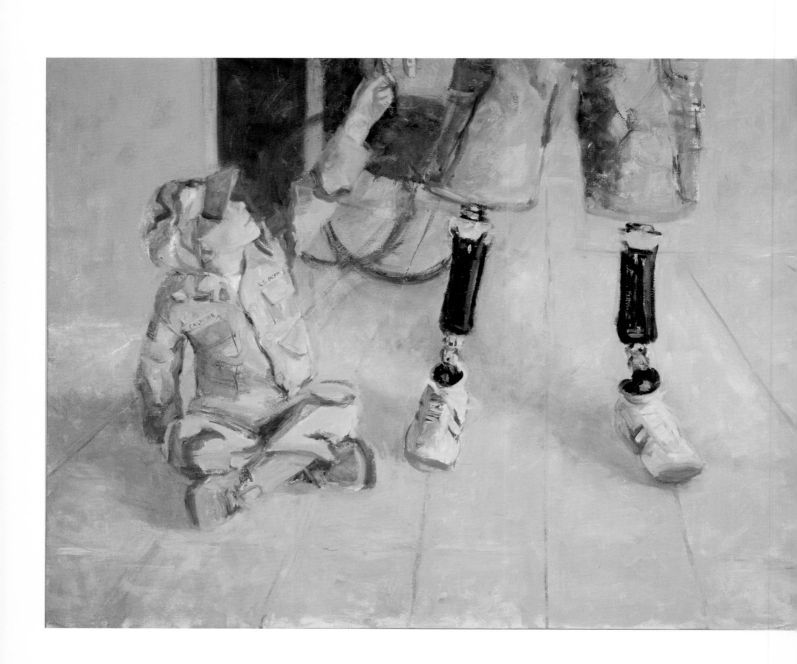

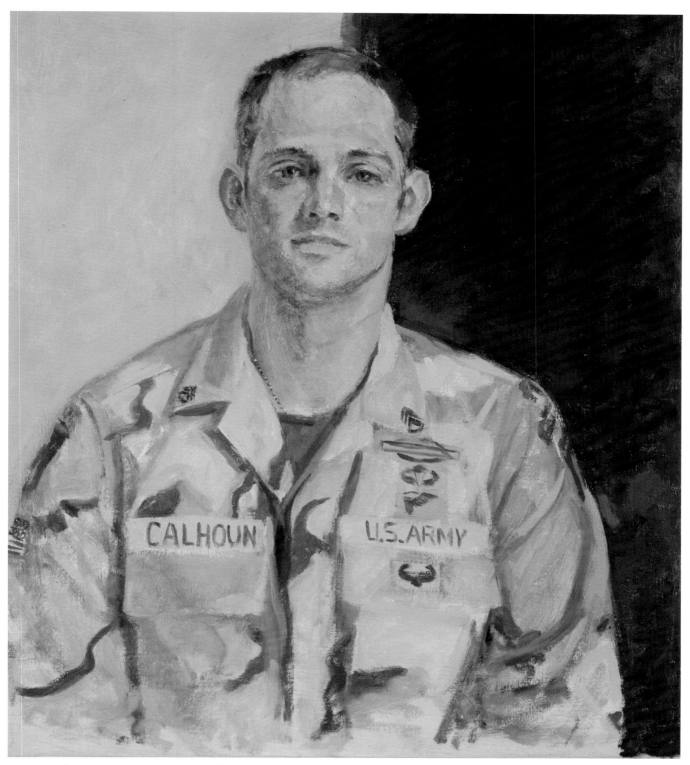

Opposite, oil on canvas, 42 x 52", 2006. Oil on canvas, 28 x 24", 2006.

PATRICIA
DEAN

The sculpture of Patricia Dean, as shown here, is a work in progress…not done yet. Which is okay because Dean herself—that's what everyone calls her—Dean herself is a bit of a work in progress. It is still not entirely clear—even though she is in her forties and a partner in a leading Denver law firm—just how she is gong to turn out. She is blazingly smart, funny, beautiful and more than a little wild. She could still do any damn thing, like a kid. Except that it is already clear that she has a character of steel. That won't change. And she walks—for all her considerable beauty—like a clumsy child. That won't change either.

Because twenty years ago, she fell off a roof ("typical Dean," one is tempted to say) and broke her neck, way up high, where it's really scary. She is an "incomplete" quadriplegic at the C2 level. If she were "complete", she would be paralyzed from the neck down and need a respirator to breath. Like Christopher Reeve.

As it is she can walk but many of her neuro systems are out of whack, so she looks like someone from Monty Python's The Bureau of Silly Walks. And she has no "proprioception"—no sense of where she is in space. So she is forever bumping into things. She has no equilibrium, either, so she needs to consciously line herself up with verticals. Like door jams and telephone poles. There's a good deal of lurching about… some crashing.

Which is fine. Because it took an agonizing year of extremely determined rehab at Craig Hospital to get this far. I know the background and, believe me, it is a triumph. And she views it precisely that way. Well, not quite: she views it as mildly hilarious and a triumph. Much of the work was done by Dean, of course. And much of it by her closest friend—and our mutual physical therapist—Conny McClintock. Conny, another of the funniest women in the West, also thinks Dean is hilarious and kids her all the time. Kids her hard. Humor is a little rough in rehab circles in the West. And no one minds it a bit. If you're in Denver some time and want to have one of the nights of your life, go drinking with Conny and Dean. But get a limo.

As I say, it is not one hundred percent clear what Dean will do when she grows up, but it is clear that she will be great at it. Because of those brains and that character I mentioned. She is already a terrific lawyer, serves on a bunch of Boards (including the Board of Craig Hospital), and is a community leader. And she is a lovely, lovely friend. With a slightly silly walk.

Work in progress, Pencil on paper, 22 x 16", 2006.

BIOGRAPHIES OF THE CONTRIBUTORS

Hilary Cooper is a portrait and landscape painter. She has done the portraits of New York Mayor Ed Koch and writers James Salter and George Plimpton, among many others. She has shown her portraits at Here Arts Center in New York and the O. Kelly Anderson Gallery. Her landscapes and still lifes have appeared in various galleries in New York and around the country. Her work has also been seen in *The New Yorker*, *New York Magazine*, *Art News*, *Aspen Magazine* and *The Harvard Advocate*. She lives in New York City and Lakeville, Connecticut with her husband, the writer Chris Crowley.

Roxana Robinson is the author of three novels: *Sweetwater* (2003), *This Is My Daughter* (1998), and *Summer Light* (1988); three short story collections, *A Perfect Stranger* (2005), *Asking for Love* (1996), and *A Glimpse of Scarlet* (1991), as well as a biography, *Georgia O'Keeffe: A Life* (1989). Four of these were named Notable Books of the Year by *The New York Times*. She has received fellowships from the NEA, the MacDowell Colony, and the Guggenheim Foundation.

Her short fiction has appeared in *The New Yorker*, *The Atlantic*, *Harper's*, *Daedalus*, *Best American Stories*, and other publications. Her essays and reviews have appeared in *The New York Times*, *Boston Globe*, *Washington Post*, *House and Garden*, *Fine Gardening*, *Travel and Leisure*, *The Wilson Quarterly*, *Vogue*, *The Wall Street Journal* and elsewhere.

She is a trustee emeritus of American PEN, and the National Humanities Center. On the Council of The Authors' Guild and the Maine Coast Heritage Trust, she has taught at the University of Houston, at Wesleyan University, and at The New School for Social Research. Her fiction has been compared to that of John Cheever by *The New York Times*, and that of Edith Wharton by *Newseek* and Jonathan Yardley of the *Washington Post* called Robinson: "One of our best writers."

Jean Kennedy Smith, founder of *VSA arts*, was the U.S. Ambassador to Ireland from 1993 to 1998. She has received numerous awards for her many contributions to the issue of disabilities, including the Jefferson Award for Outstanding Public Service from the American Institutes for Public Service, the Margaret Mead Humanitarian Award from the Council of Cerebral Palsy Auxiliaries, and the 1997 Terence Cardinal Cooke Humanitarian Award. She has four children.

VSA arts is an international nonprofit organization founded in 1974 by Ambassador Jean Kennedy Smith to create a society where people with disabilities learn through, participate in and enjoy the arts. *VSA arts* provides educators, parents, and artists with resources and the tools to support arts programming in schools and communities. *VSA arts* showcases the accomplishments of artists with disabilities and promotes increased access to the arts for people with disabilities. Each year millions of people participate in *VSA arts* programs through a nationwide network of affiliates and in more than 60 countries around the world. *VSA arts* is an affiliate of the John F. Kennedy Center for the Performing Arts. For more information visit *www.vsarts.org*

ACKNOWLEDGEMENTS

Chronologically, thanks to the EMTs and emergency room doctors and nurses who knew how to handle a spinal cord injury. To my surgeons, Drs. Alec Jones and Steve Johnson, for waking in the middle of the night to operate for hours and hours as well as their wonderful and sustaining friendship since. To Dr. Bob Menter who taught me that bowel and bladder functions are *the* key to life. To my "team" at Craig Hospital, especially Conny McClintock, my laugh therapist and super supporter of this project, and James, my main tech, who took such good care of my body as it took its vacation from me. To the many wonderful supportive friends and acquaintances too numerous to mention here who wrote, visited, and generally gave me heart in those first months. To Helen Ward and Bobo Devens, for all their invaluable suggestions. To Dede Reed and the Peter S. Reed Foundation for giving me the financial boost to get this project going. To Marnie Pillsbury for connecting me to Visible Theater and to Krista Smith for suggesting a collaboration that launched the first showing of *Divided Portraits* with the True Story Project. To Jaren Ducker and the Denver Public Library, especially Joan Harms and Jim Kroll there. To Damon McLeese who brought the show to his organization, *VSA arts of Colorado*, and who suggested the book be created. For editing help on "Grazed" I cannot thank Kay Eldredge enough for pouring over it with a fine tooth comb and to Laura Yorke for its penultimate professional edit. To Harry Lodge for all his brotherly advice. To Erin Harney, Laura McBride and Unha Kim for a beautiful book design. Finally, and especially, to Nan Richardson of Umbrage Editions for giving this project its own life.

To my brother, Christopher Albert Cooper 1960-2004. Difficult lives are no less precious than charmed ones; in his case, even more valuable. I miss him terribly.

To my husband, Chris Crowley, an extraordinary writer whose voice can be heard quite clearly in a number of the bios he helped me edit. Because of him my life is charmed.

Resources

The following listing focuses on people and organizations related to disabilities mentioned in this book. A further selected list of the general web resources for information are listed below.

Craig Hospital

Denver, Colorado. A leading rehabilitation hospital specializing in the rehabilitation and research of spinal cord injury and traumatic brain injury.

www.craighospital.org

Visible Theatre

New York, New York. Holistically cultivates artists and incubates original work, celebrating alternative perspectives, challenging perceptions and providing unique insight into the human condition. Visible believes that the provocative voice of the artist can create positive, lasting social change. True Story Project (which features three of Divided Portraits subjects), includes as a goal, "getting at truths that lie deeper than disability".

www.visibletheatre.org

Wounded Warrior Project

Roanoake, Virginia. Provides programs and services for men and women of our armed forces who have been severely injured during the conflicts in Iraq, Afghanistan, and other locations around the world, to ease the burdens of the wounded and their families, aid in the recovery process, and smooth their transition back to civilian life.

www.woundedwarriorproject.org

Miss Liz, Inc.

New York, New York. Liz Treston is an outstanding motivational speaker (and subject in *Divided Portraits*) who offers presentations on disabilities issues.

www.missliz.org

Challenge Aspen

Aspen, Colorado. Co-founded by Amanda Boxtel (included in *Divided Portraits*), Challenge Aspen provides recreational and cultural experiences for individuals who have mental or physical "disabilities" and their family and friends. Amanda herself is also a compelling motivational speaker.

www.amandaboxtel.com

www.challengeaspen.com

The Heuga Center

Edwards, Colorado. A non-profit organization, founded by former Olympic skier Jimmie Heuga, dedicated to improving the lives of people with multiple sclerosis through educational and wellness programs focused on exercise and lifestyle changes, and ongoing research.

www.heuga.org

Other Resources

National Coalition of Disability Rights www.ncdr.org

Christopher Reeve Paralysis Foundation www.crpf.org

Canadian Paraplegic Organization
www.canaparplegic.org

Coalition for the Advancement of Medical Research
www.camr.org

Spinal Cord Association www.spinal-cord.org

Shake-A-Leg www.shakealeg.org

American Paraplegia Association www.apa.org

VSA arts www.vsarts.org

We gratefully thank Sarah Redlich Johnson for her generous support
of the book and exhibition. Grateful thanks also to The Mary Conover
Foundation for their gift of support.

Divided Portraits

An Umbrage Editions Book

First Edition

ISBN 978-1-884167-64-5

An Umbrage Editions book
Publisher: Nan Richardson
Design: Unha Kim
Production and Editorial Assistant: Eli Spindel
Exhibitions Coordinator: Meg Gibson
Assistant Designer: Katherine Casiano
Copyeditor: Katherine Parr

Umbrage Editions, Inc.
515 Canal Street
New York, New York 10013
www.umbragebooks.com

Distributed by Consortium in North America
www.consortium.com

Distributed by Turnaround in Europe
www.turnaround.uk

Printed in Canada.